Simon's Cat ©

THE BUMPER BOOK OF Simon's Cat©

by Simon Tofield

CANONGATE
Edinburgh · London

First published in Great Britain in 2013 by Canongate Books Ltd,
14 High Street, Edinburgh EH1 1TE

www.canongate.tv

1

Illustrations copyright © Simon Tofield, 2009-2013

The moral right of the author has been asserted

Simon's Cat (2009), Simon's Cat: Beyond the Fence (2010), Simon's Cat in Kitten Chaos (2011)
were first published in Great Britain by Canongate Books Ltd

British Library Cataloguing-in-Publication Data
A catalogue record for this book is available on request from the British Library

ISBN 978 0 85786 079 8

Typeset by Simon's Cat

Printed and bound in Italy by Grafica Veneta S.p.A.

For my Zoë

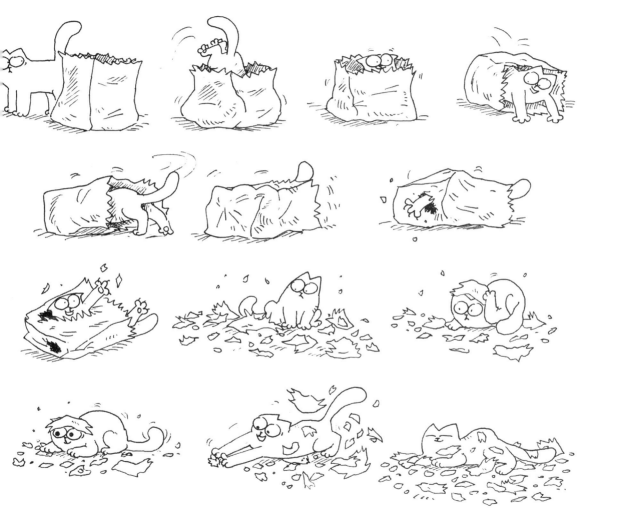

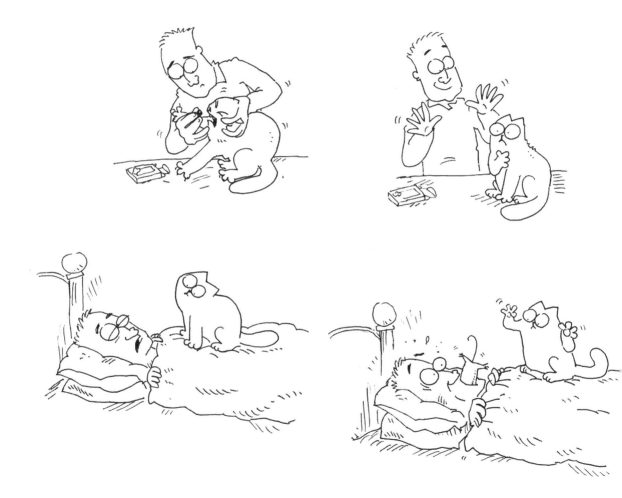

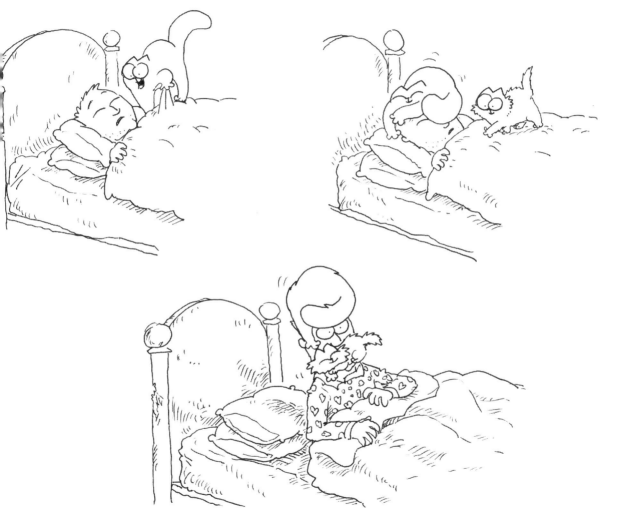

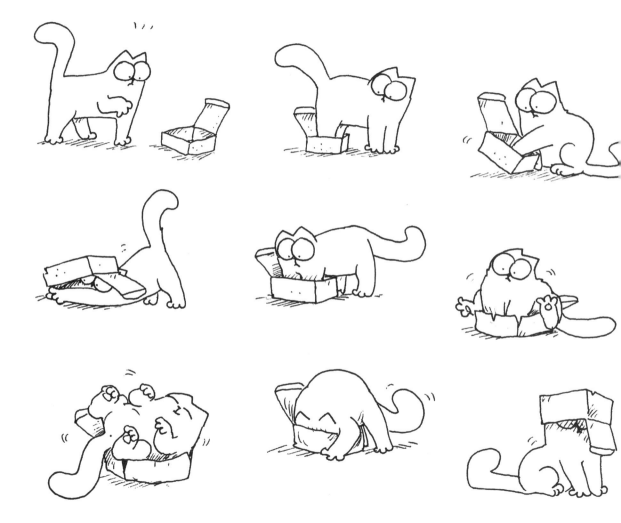

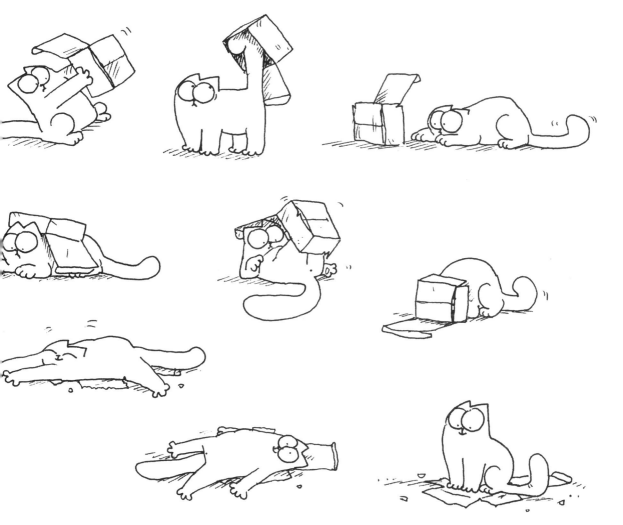

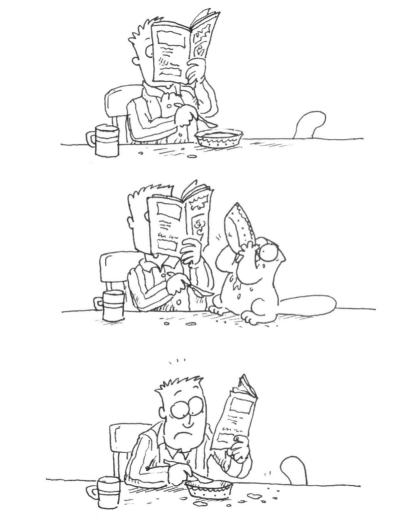

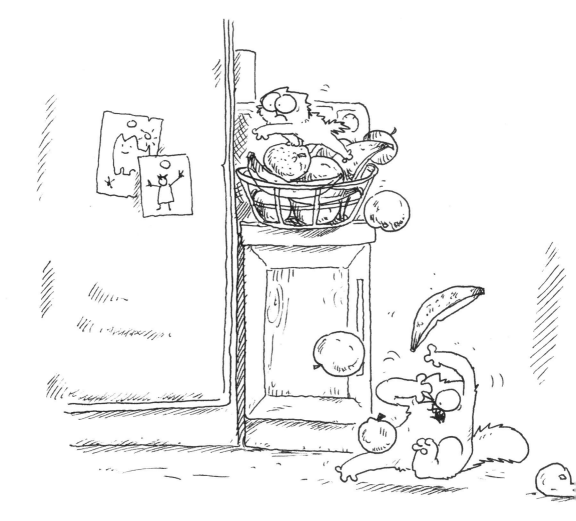

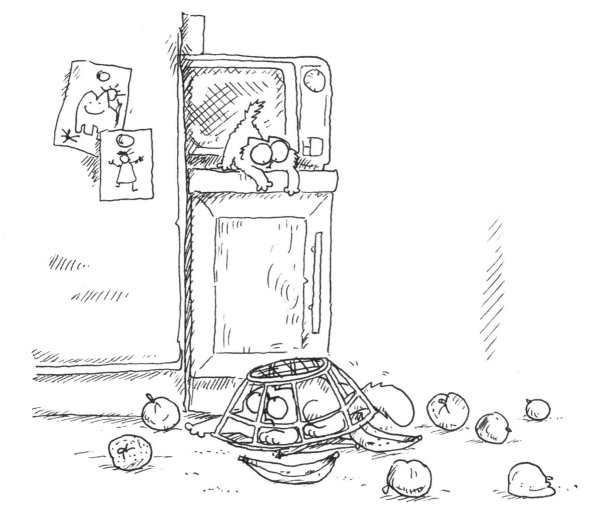

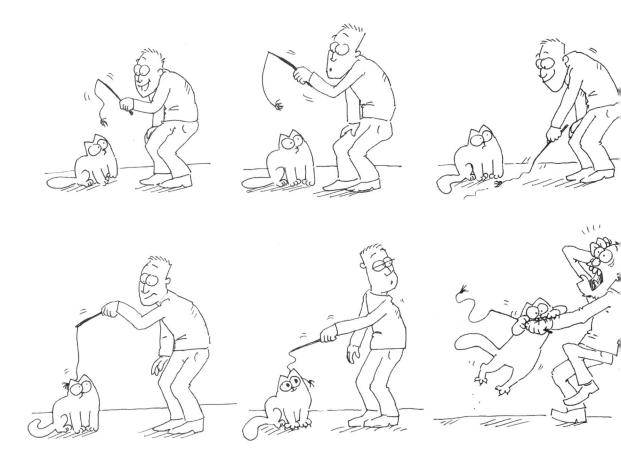

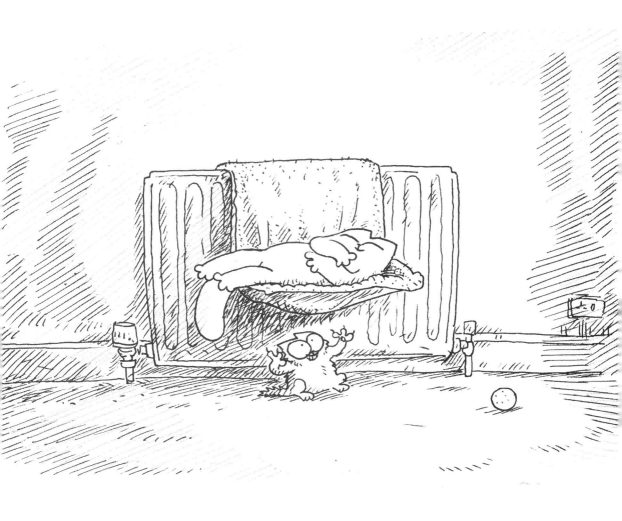

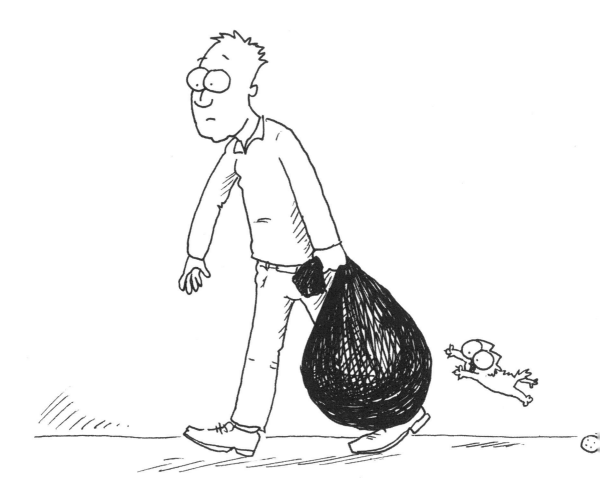

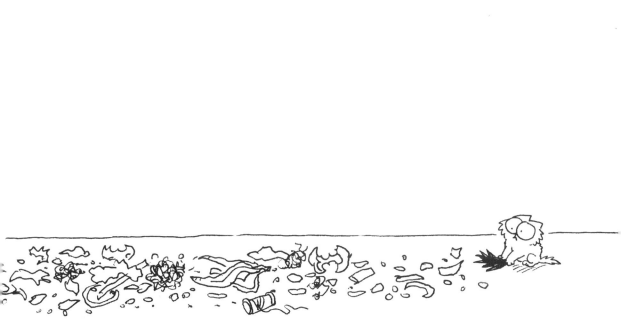

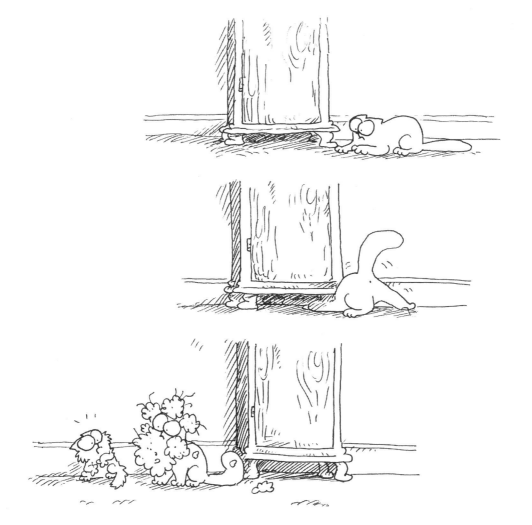

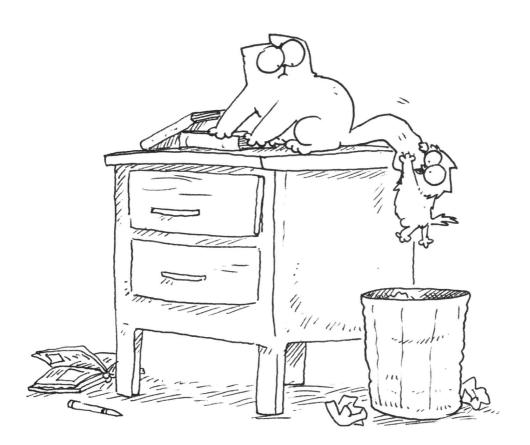

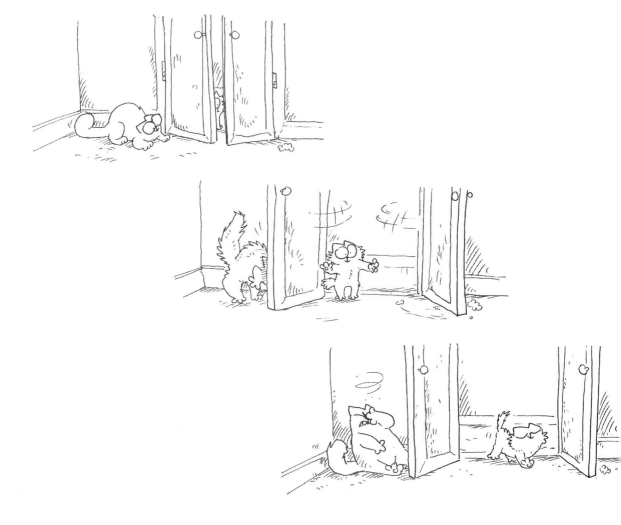

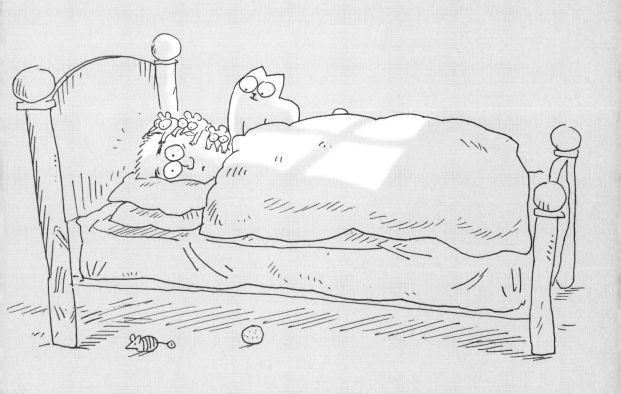

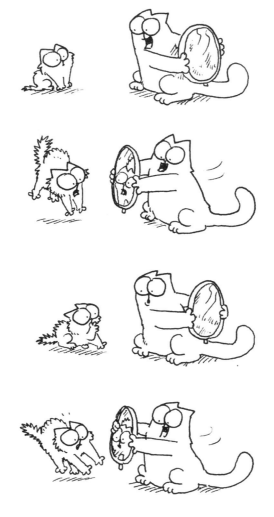

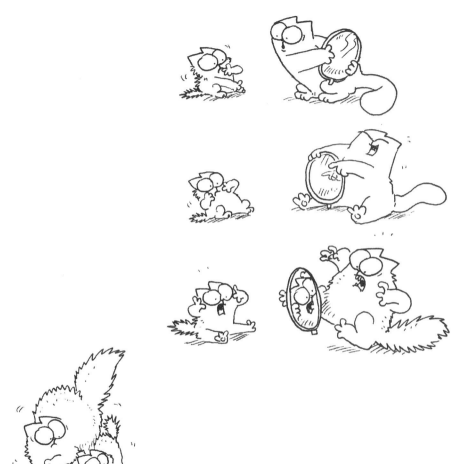

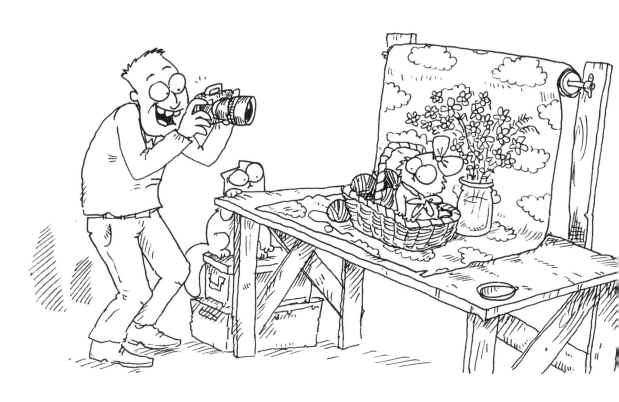

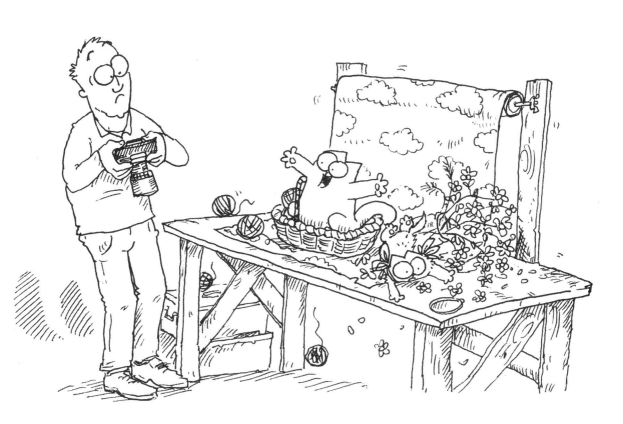

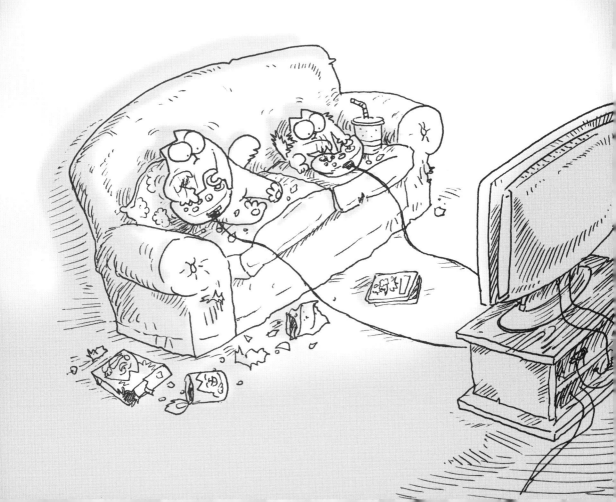

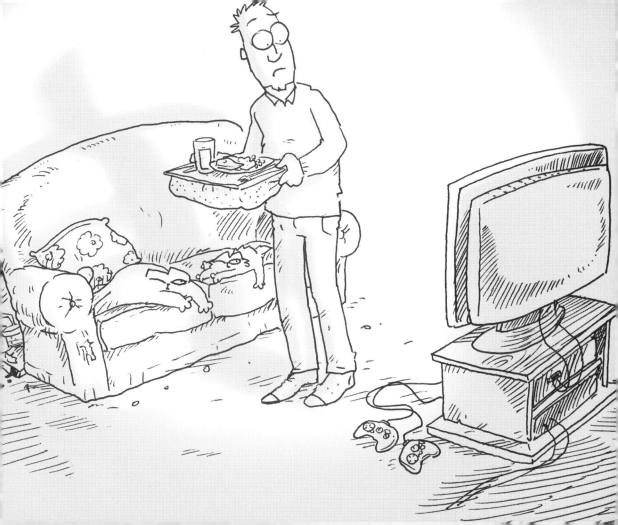

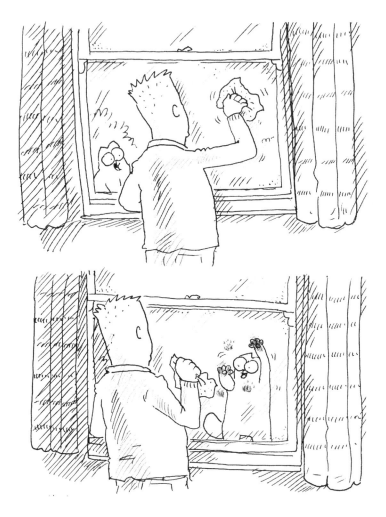

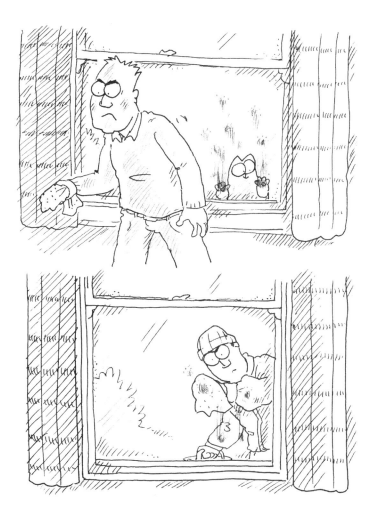

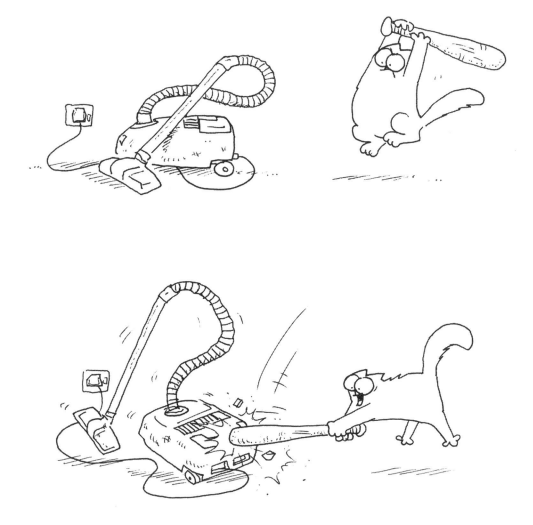

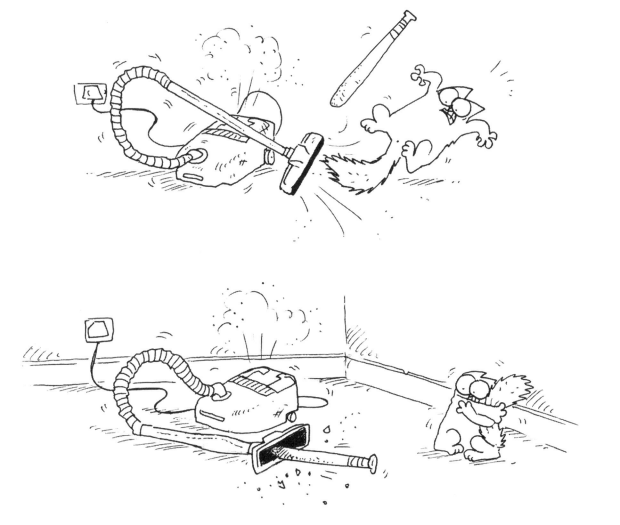

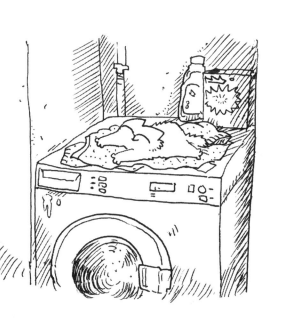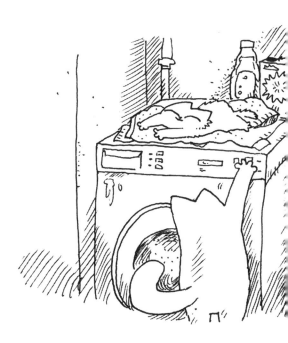

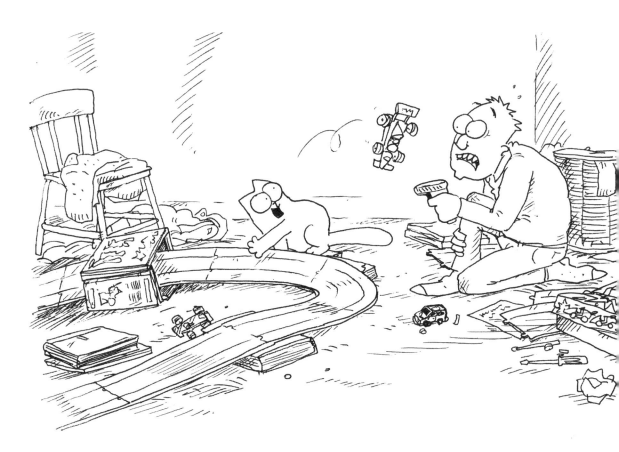

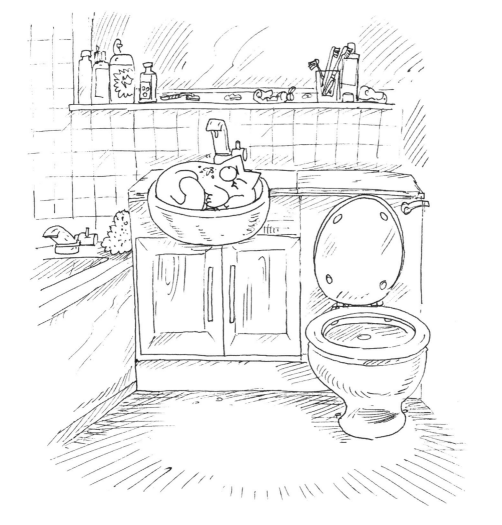

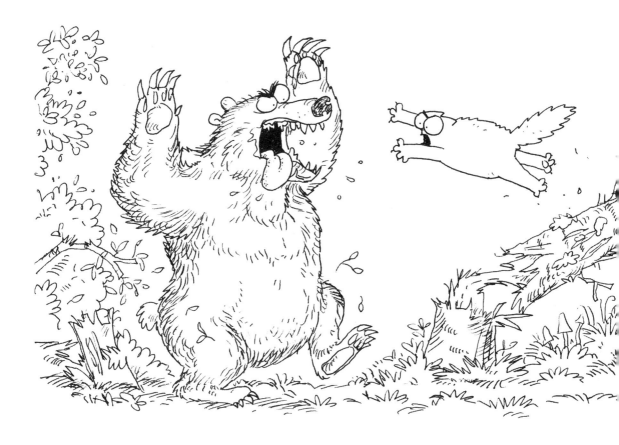

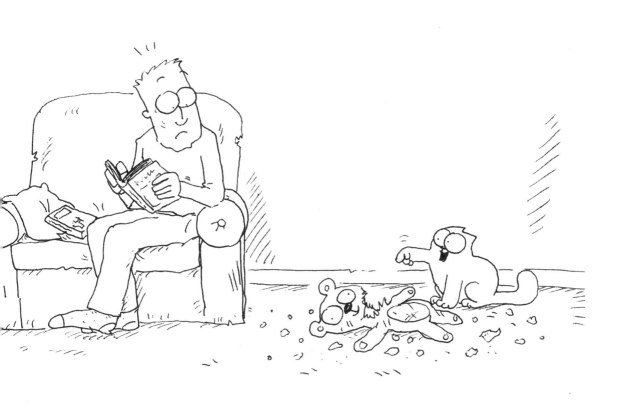

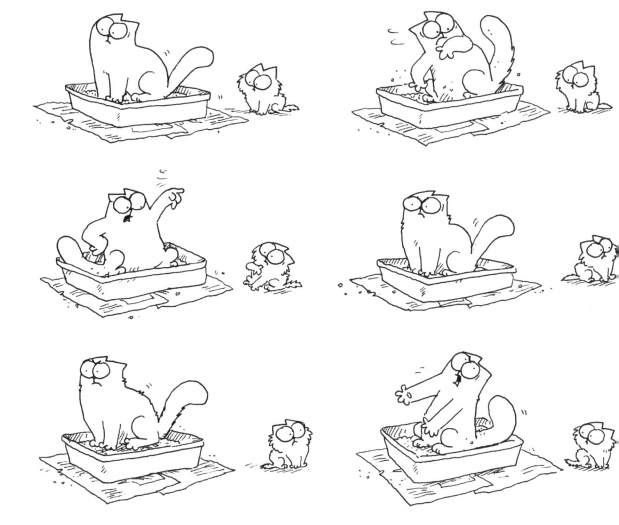

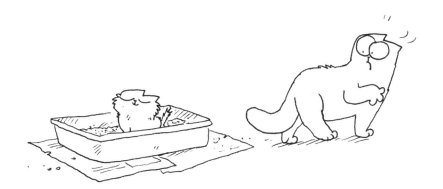

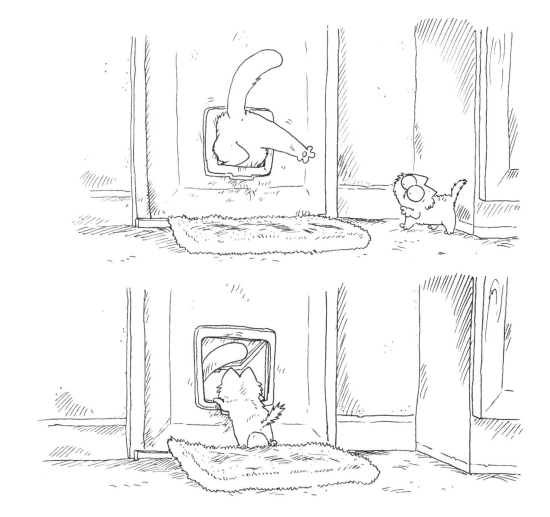

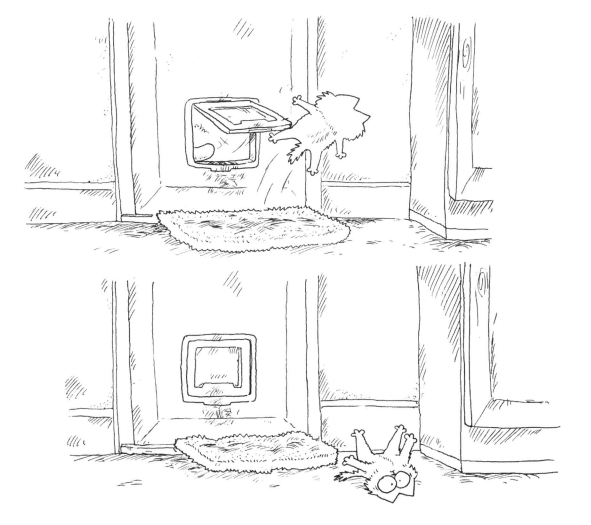

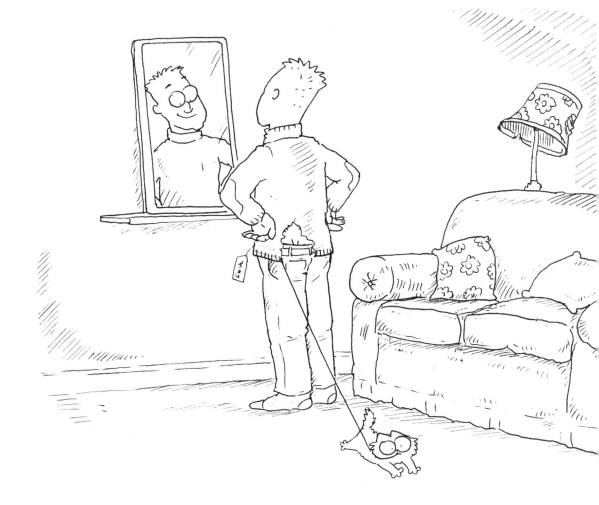

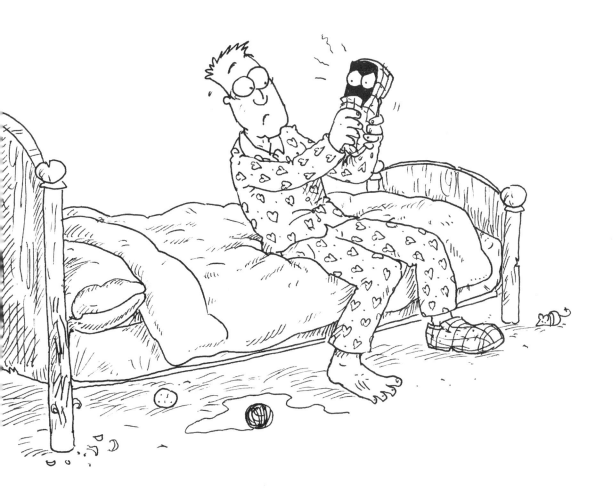

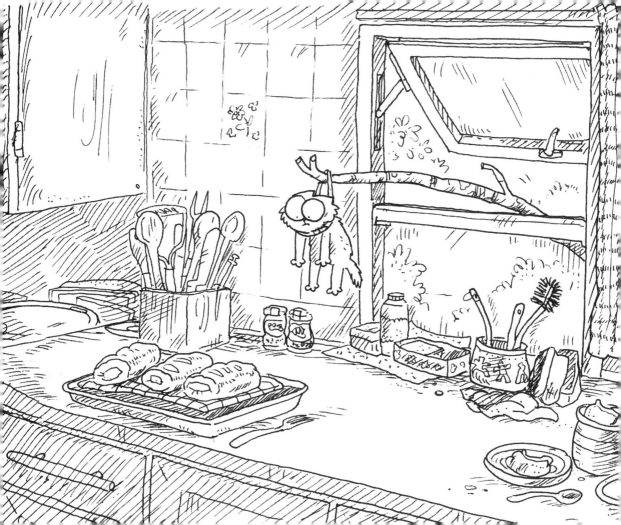

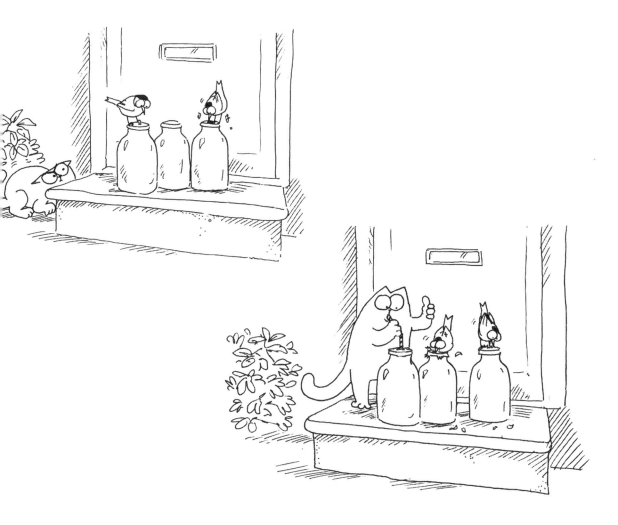

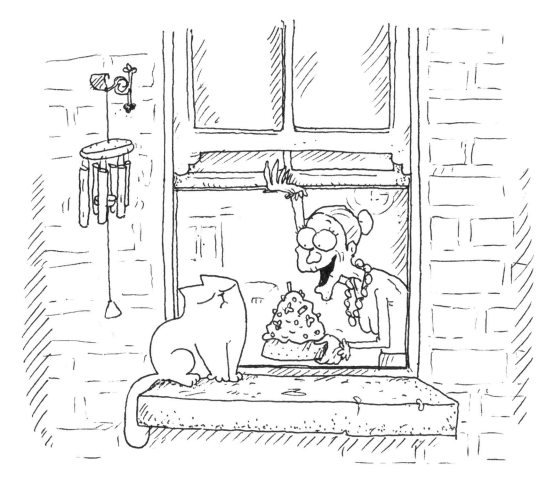

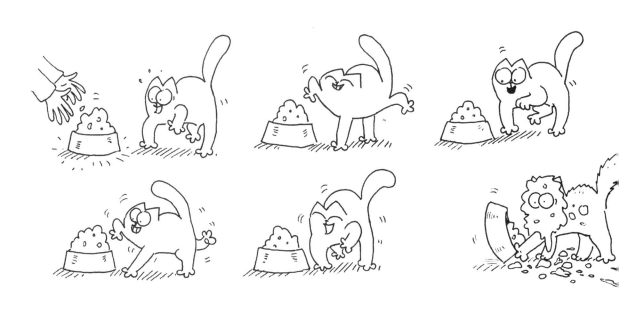

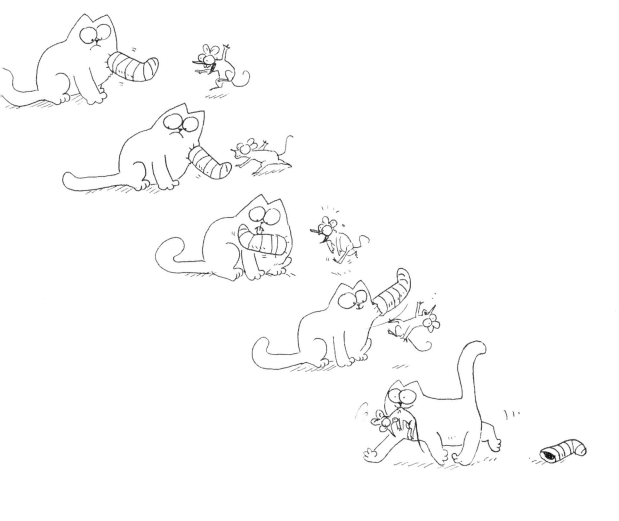

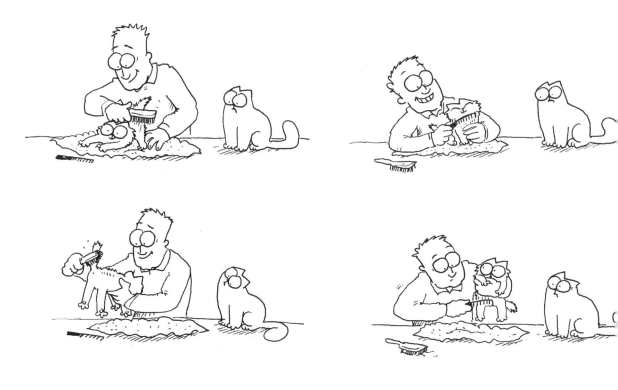

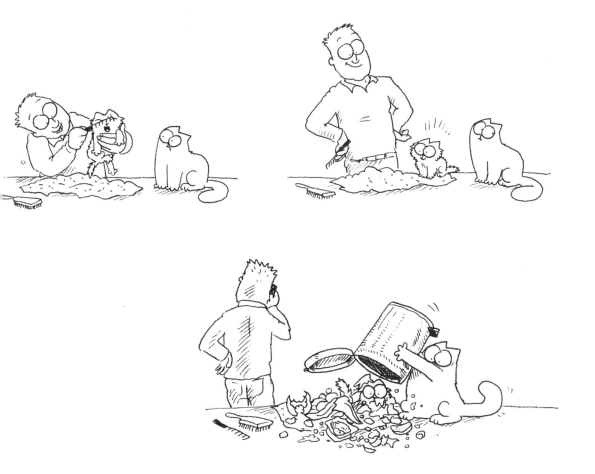

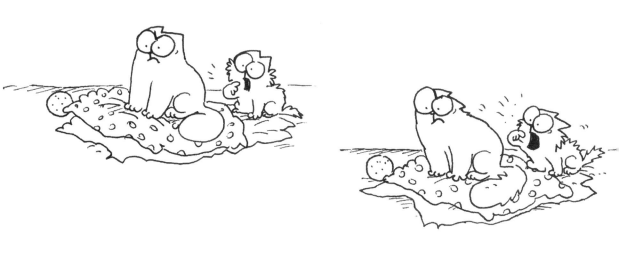

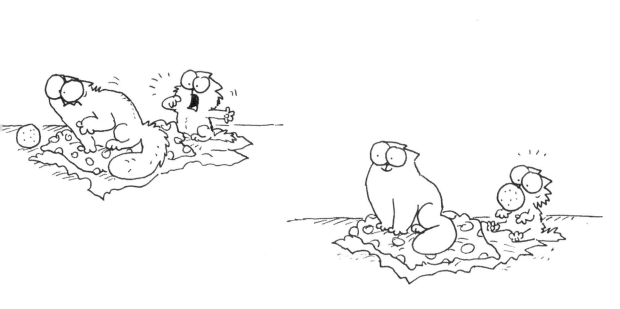

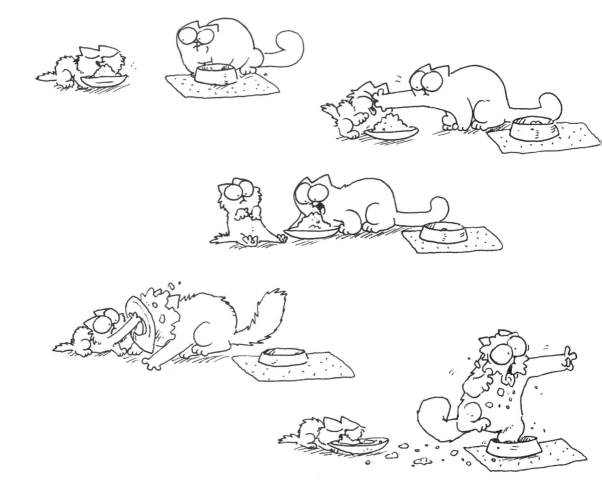

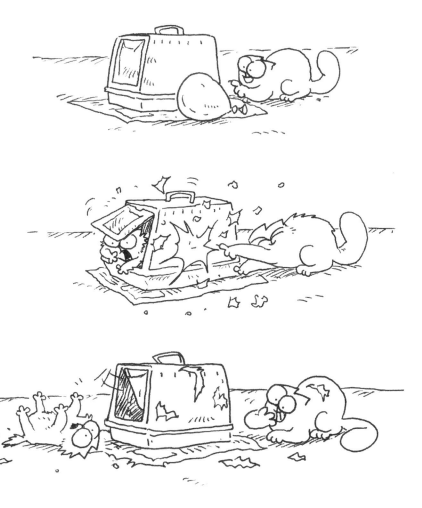

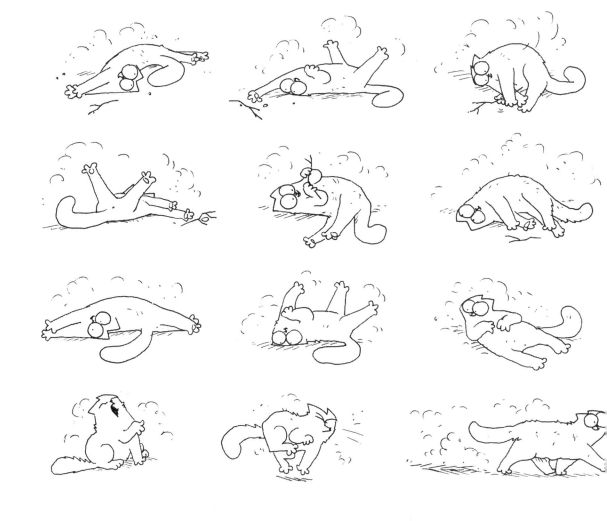

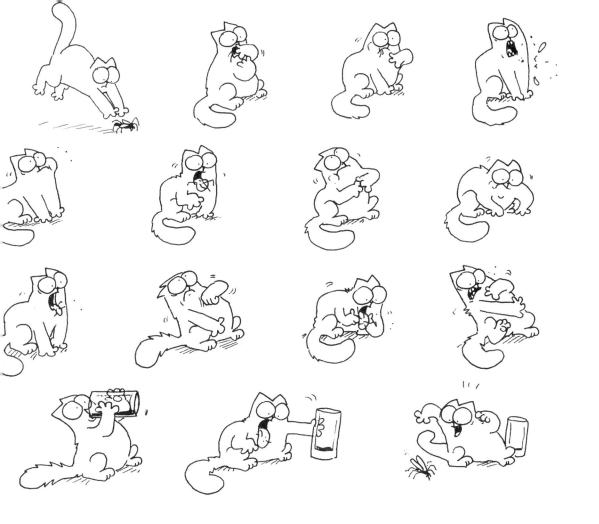

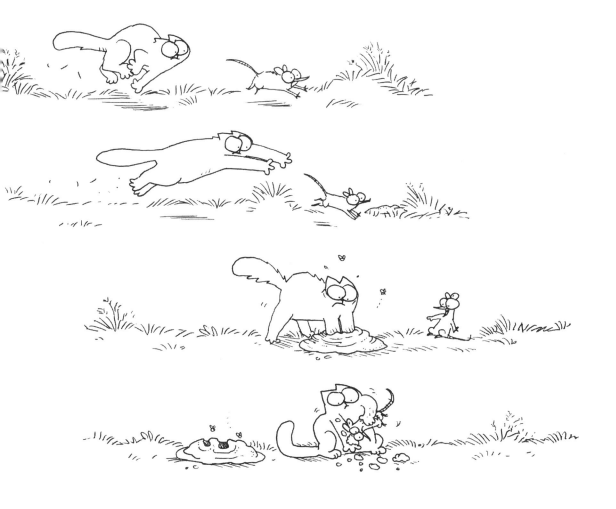

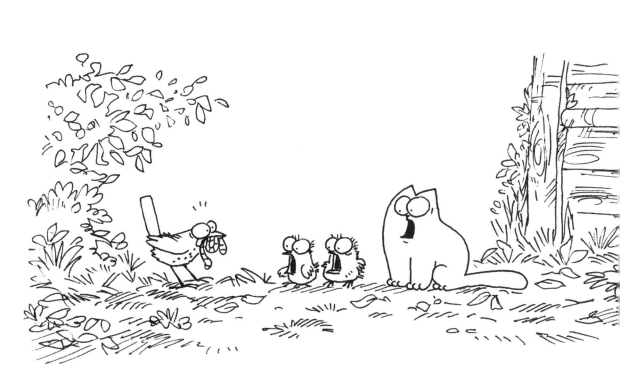

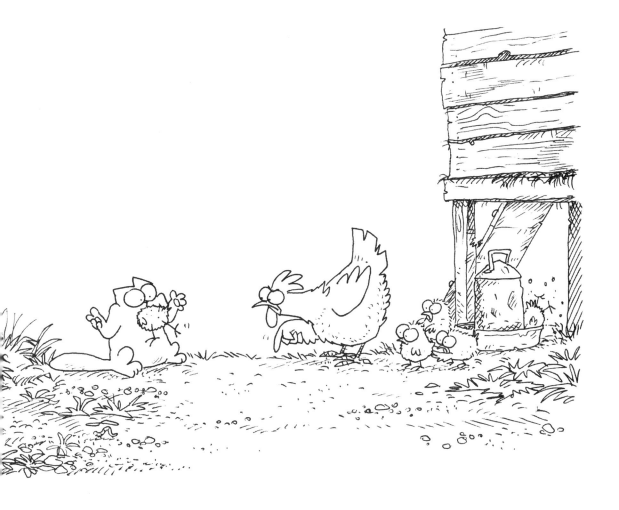

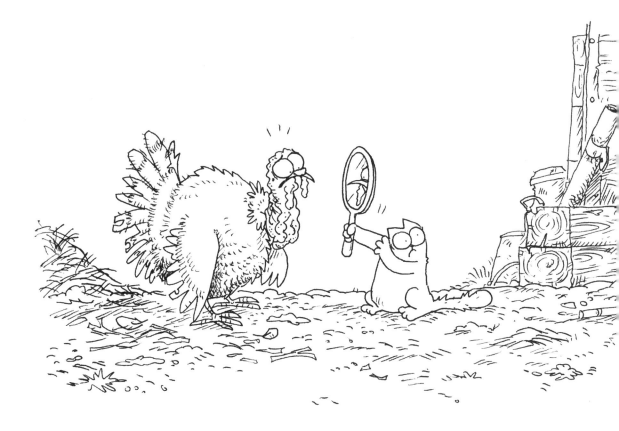

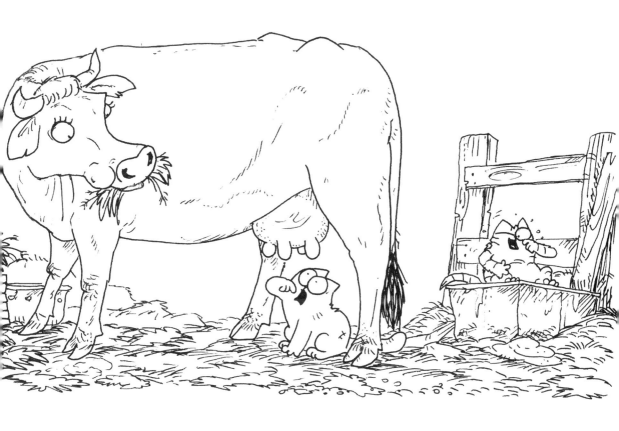

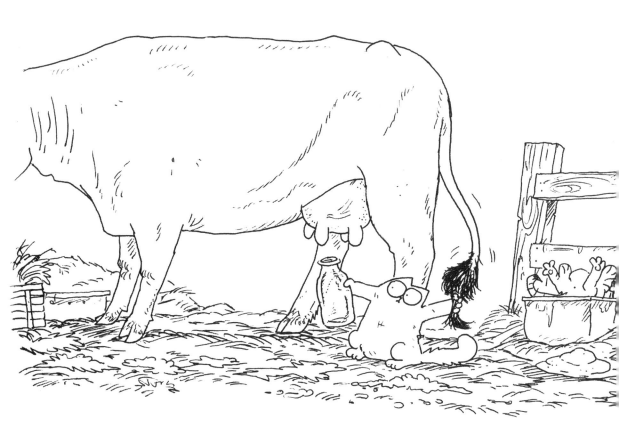

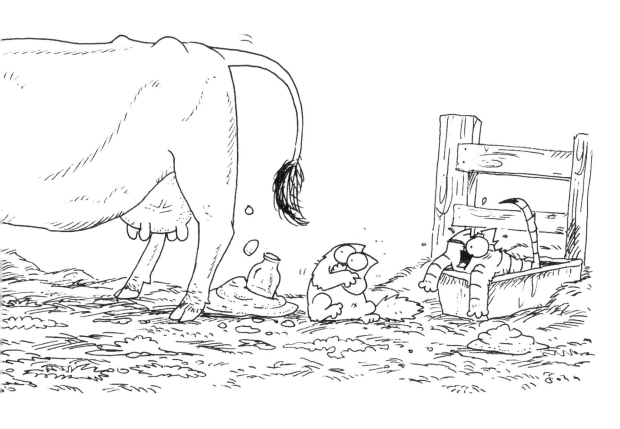

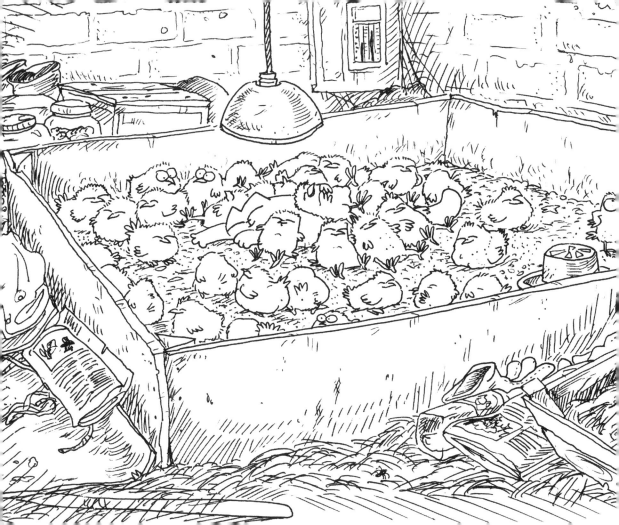

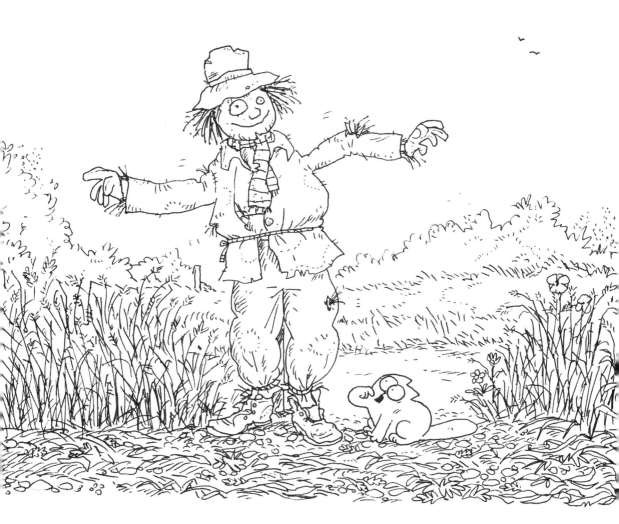

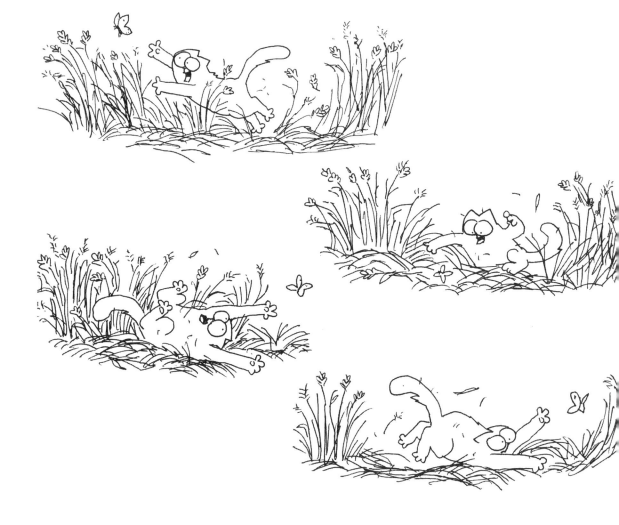

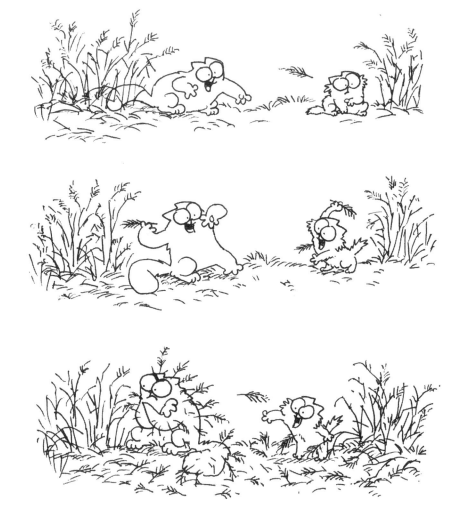

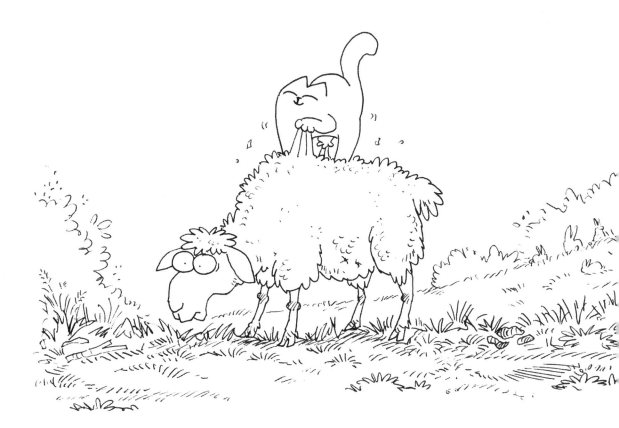

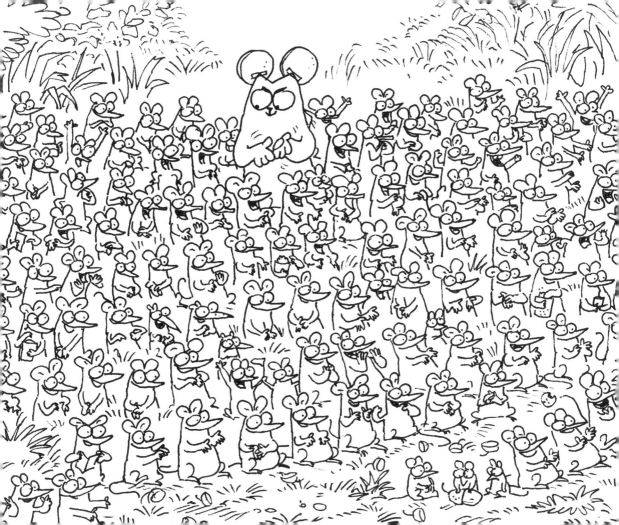

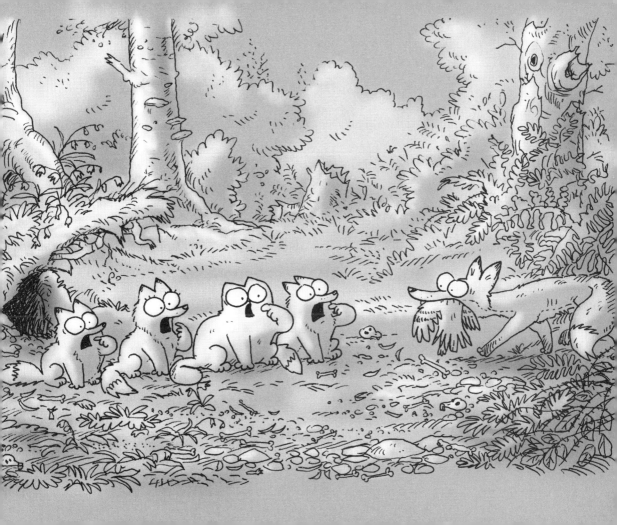

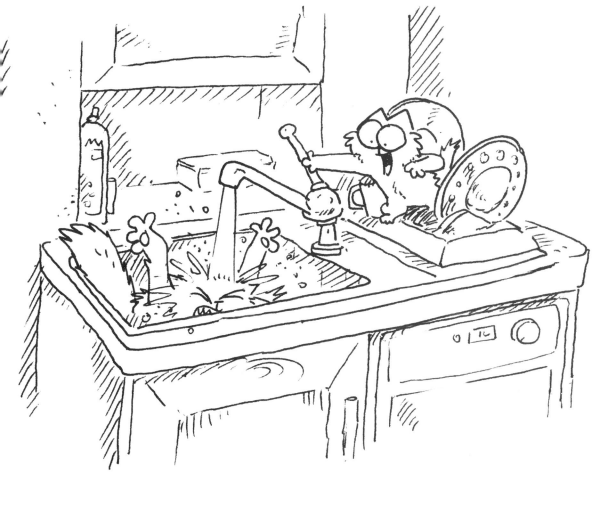

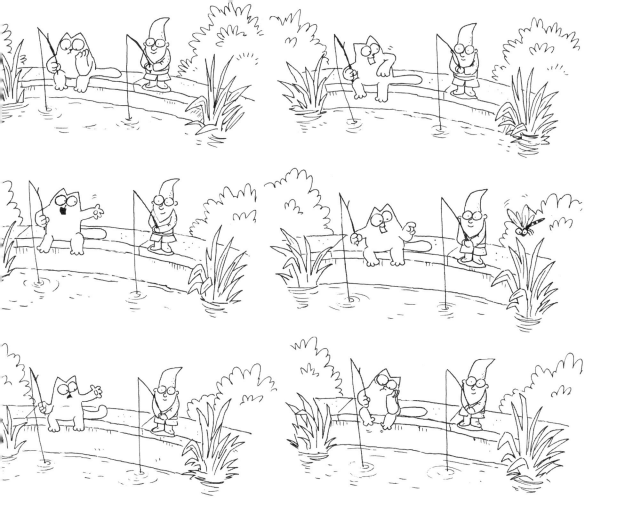

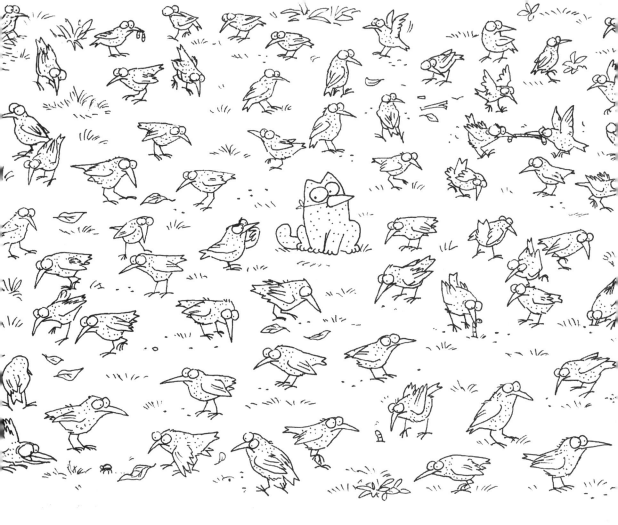

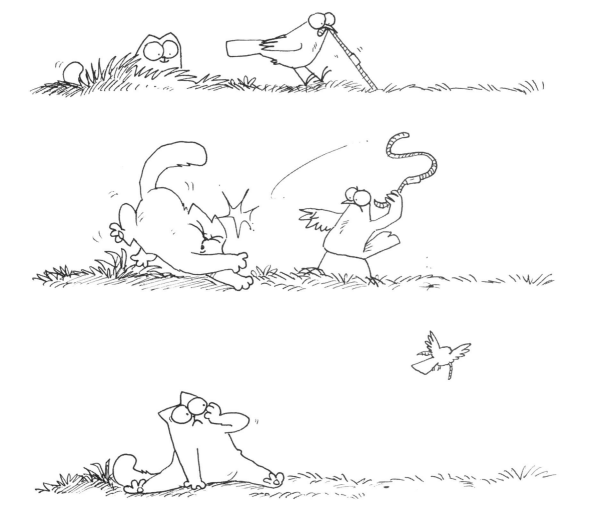

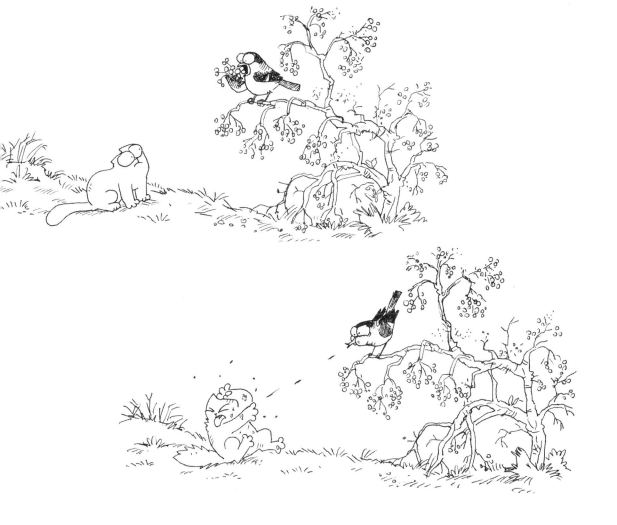

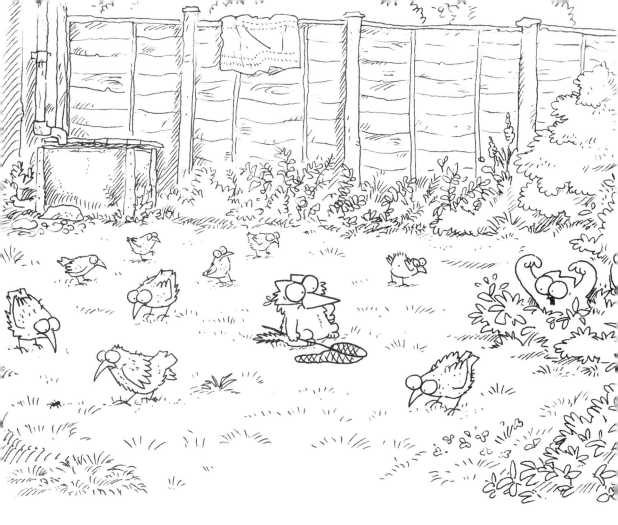

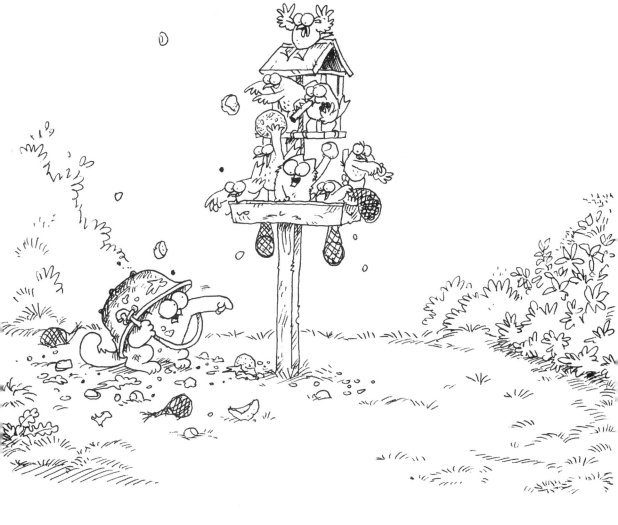

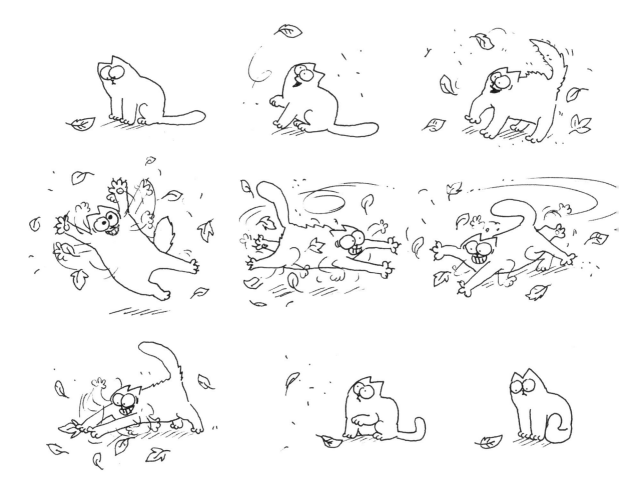

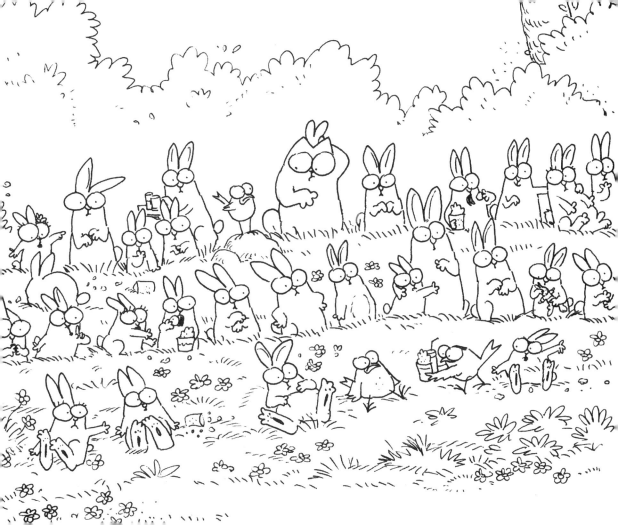

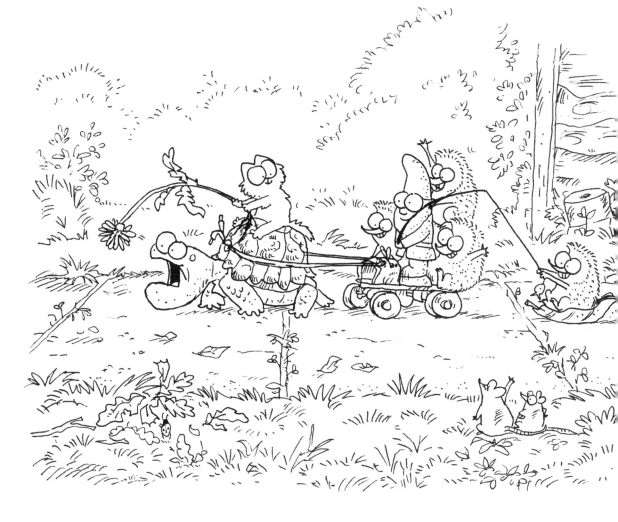

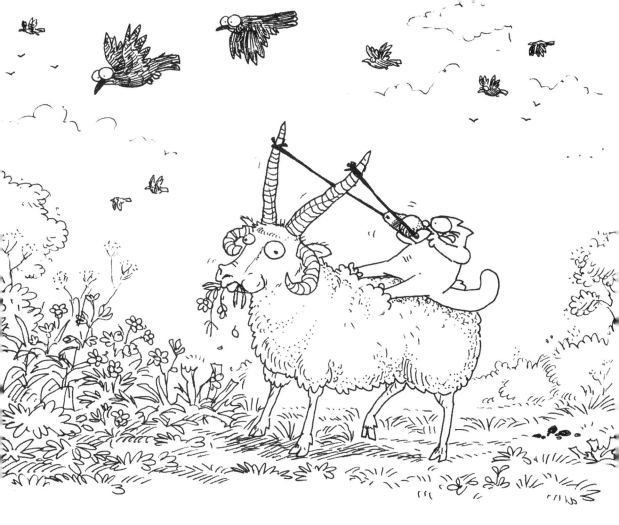

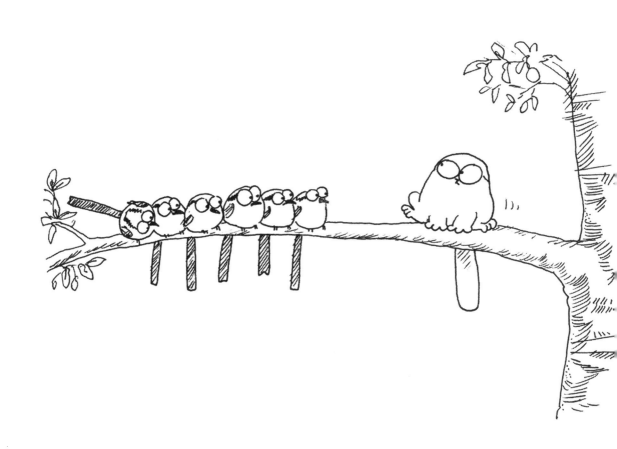

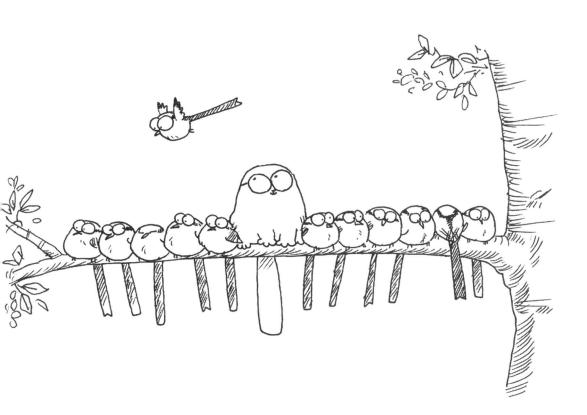

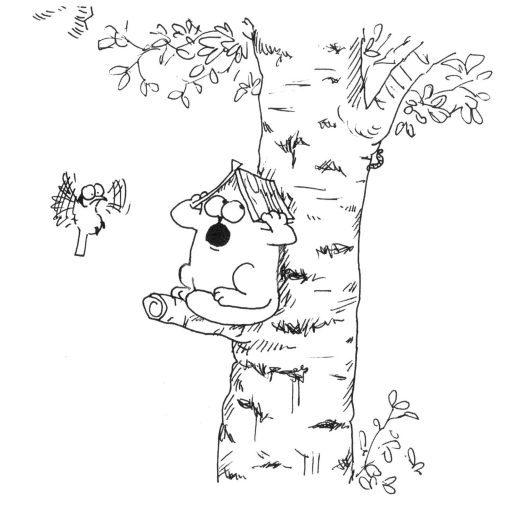

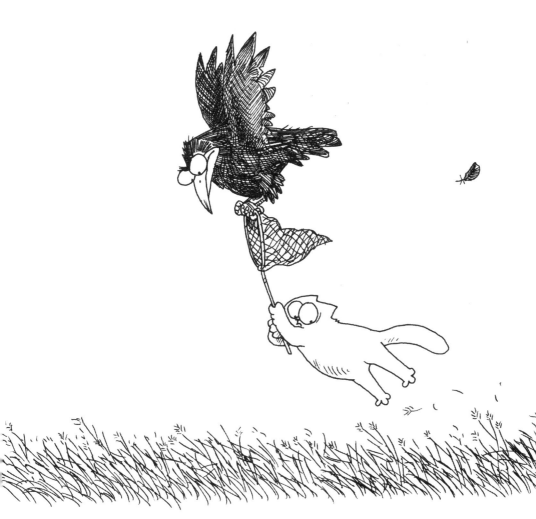

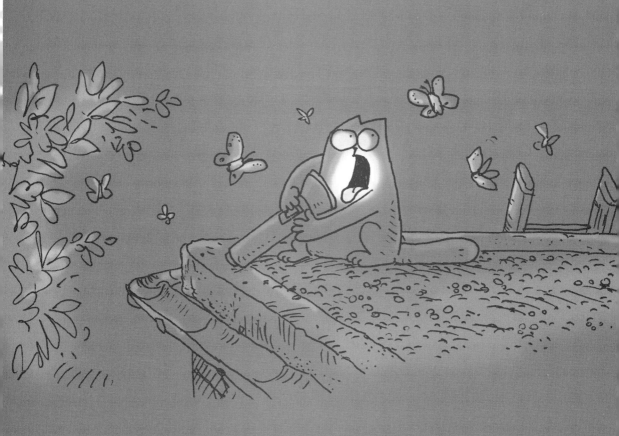

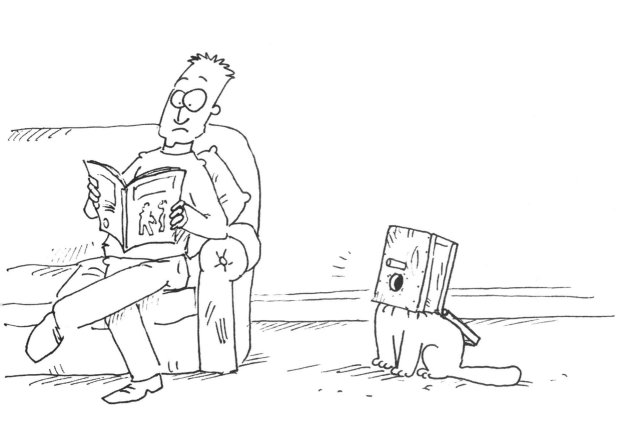

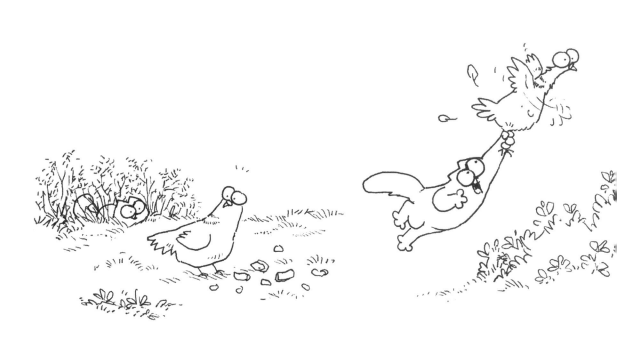

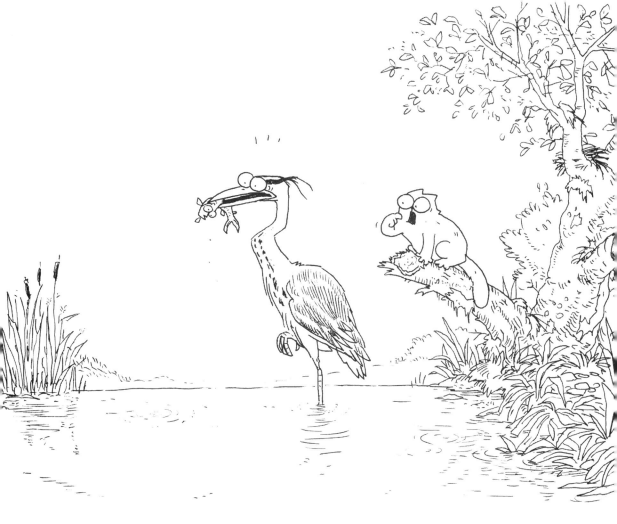

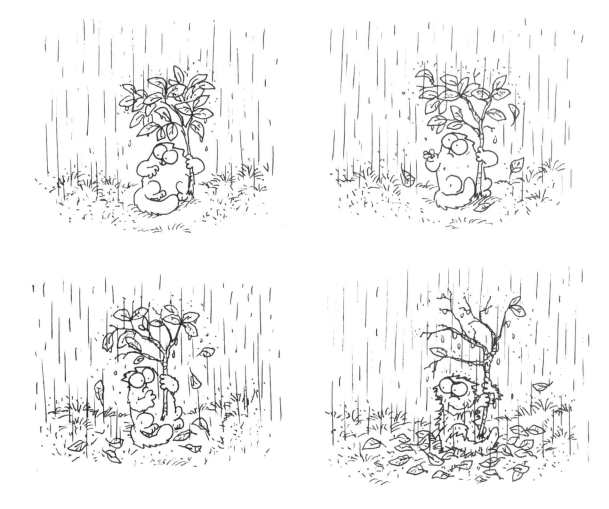

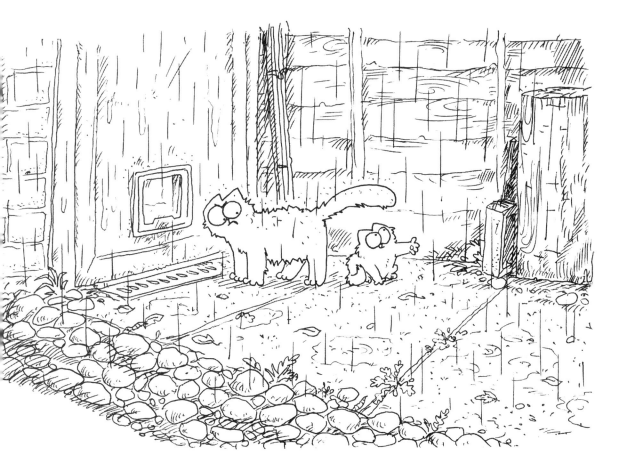

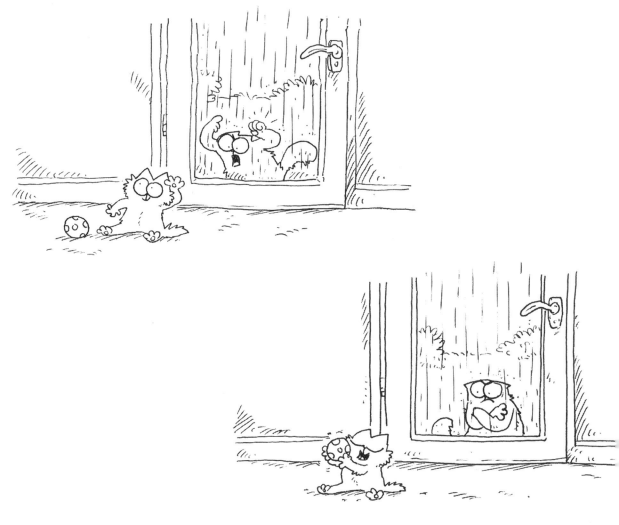

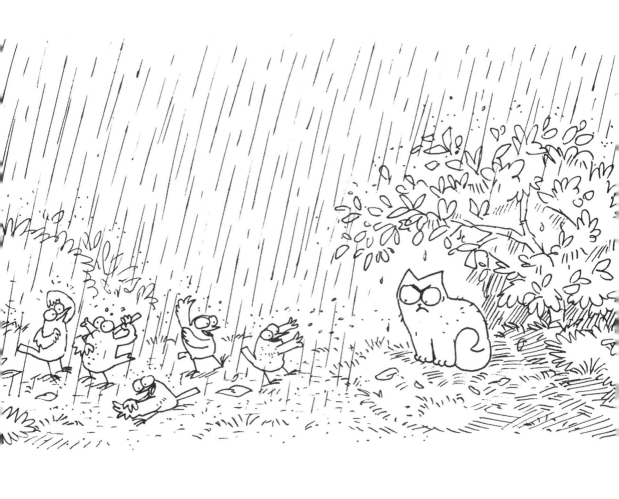

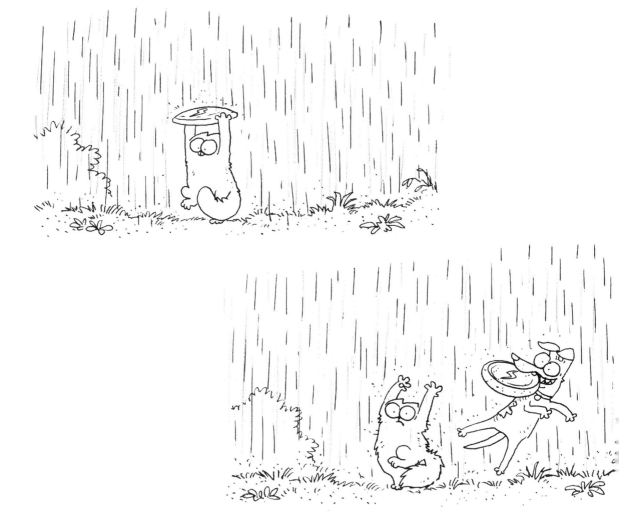

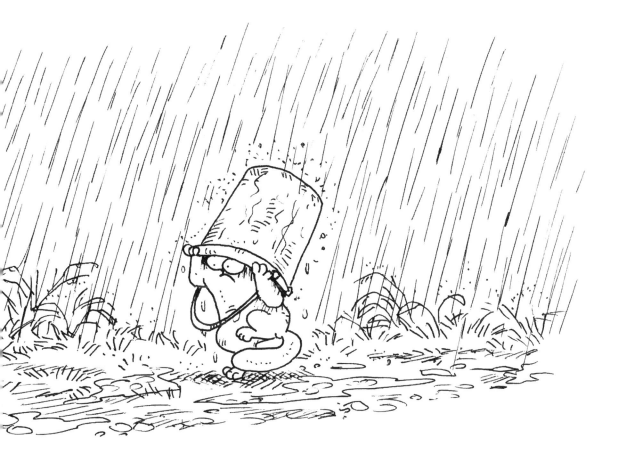

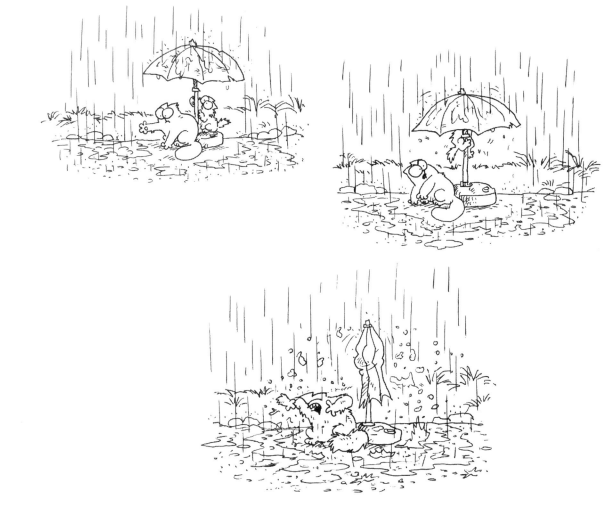

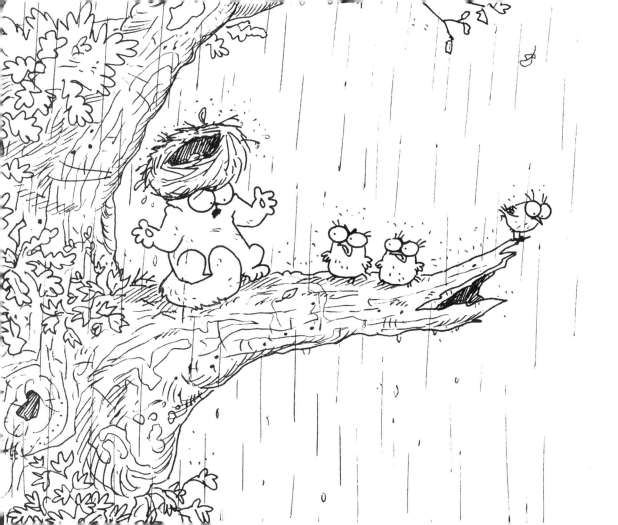

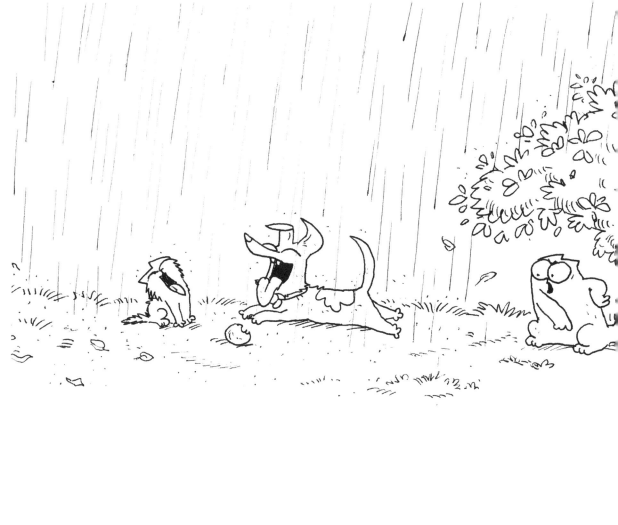

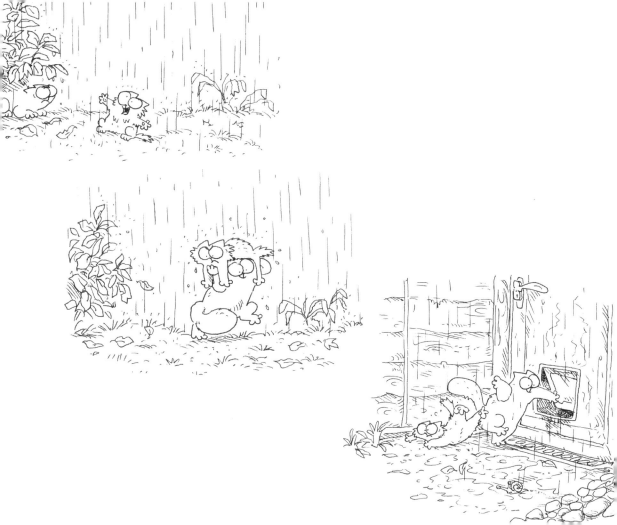

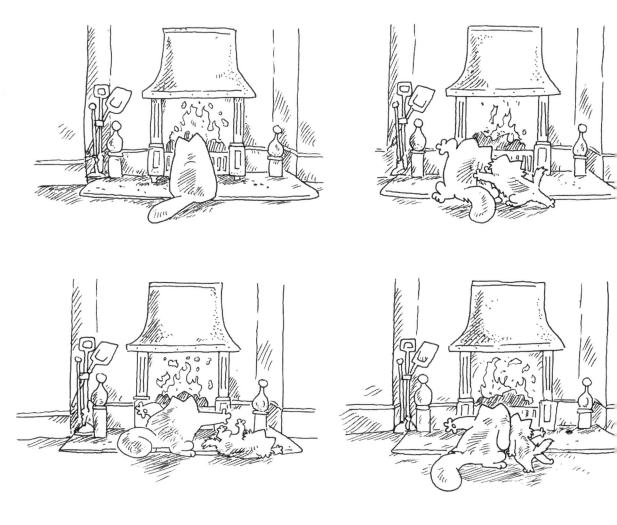

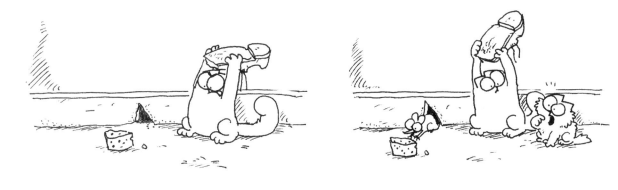

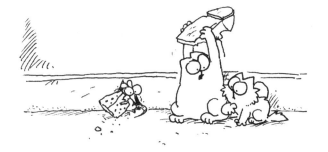

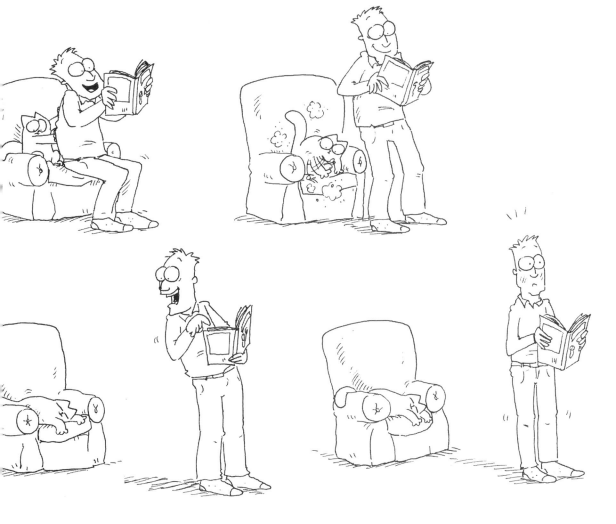

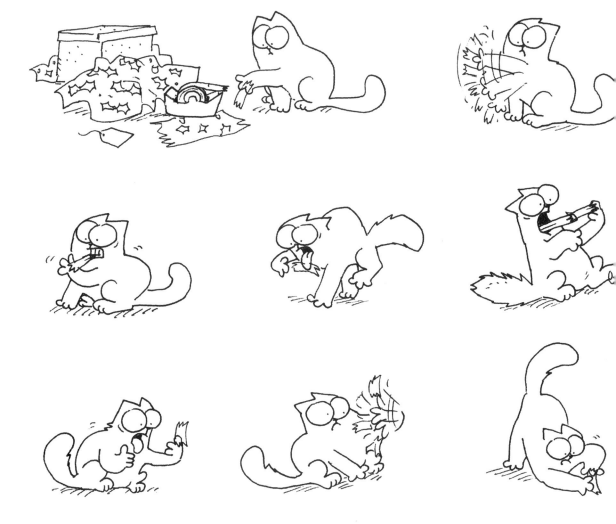

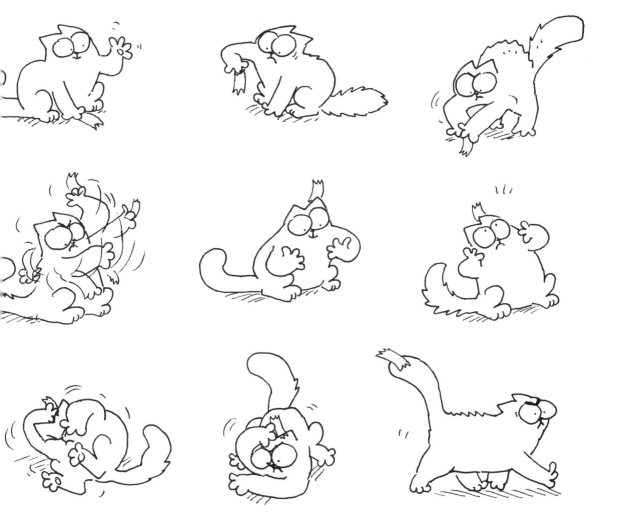

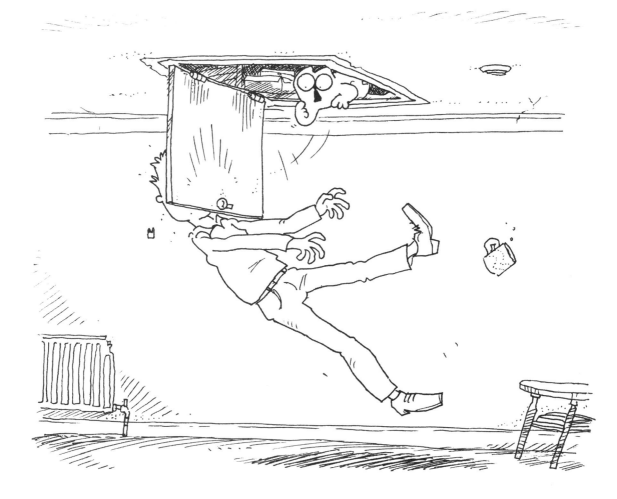

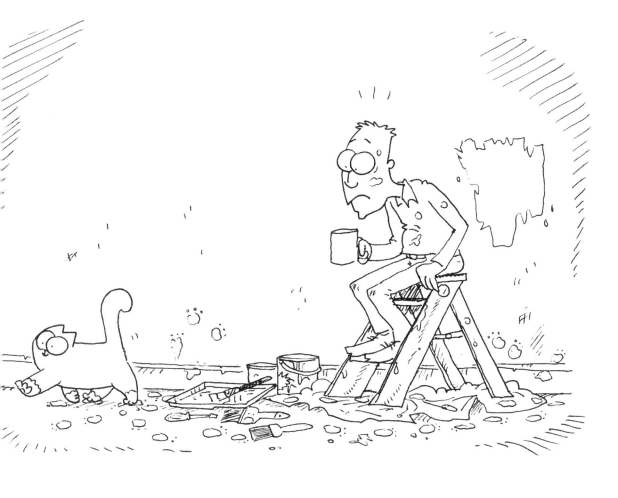

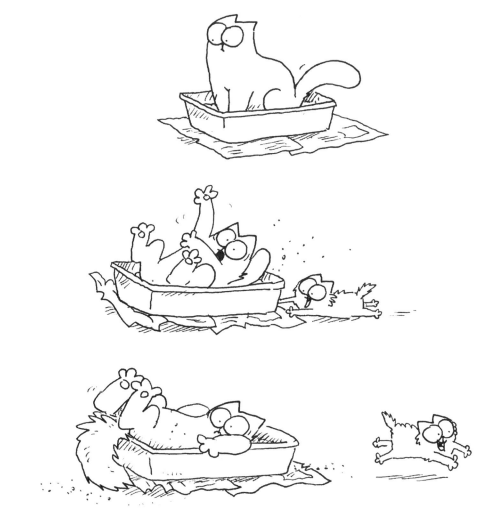

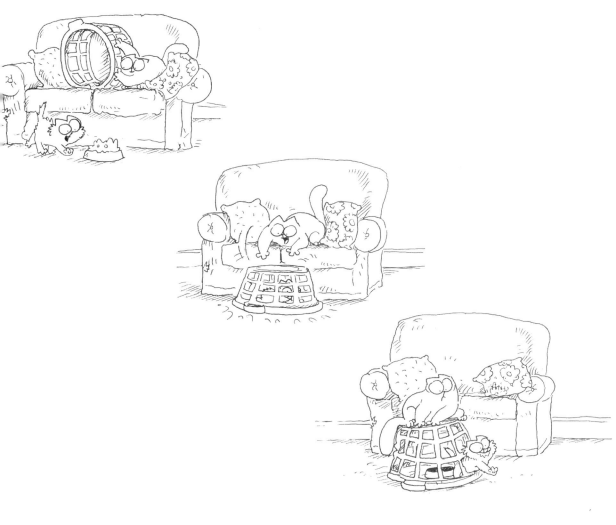

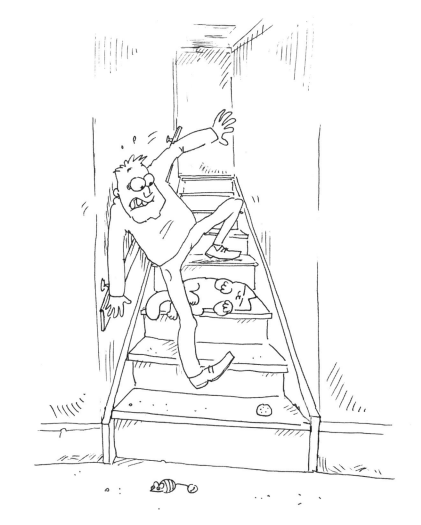

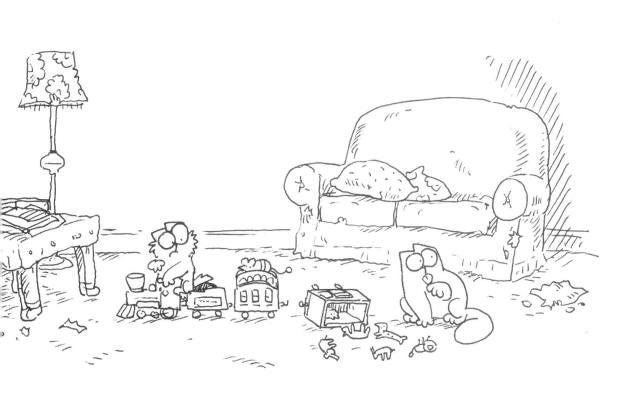

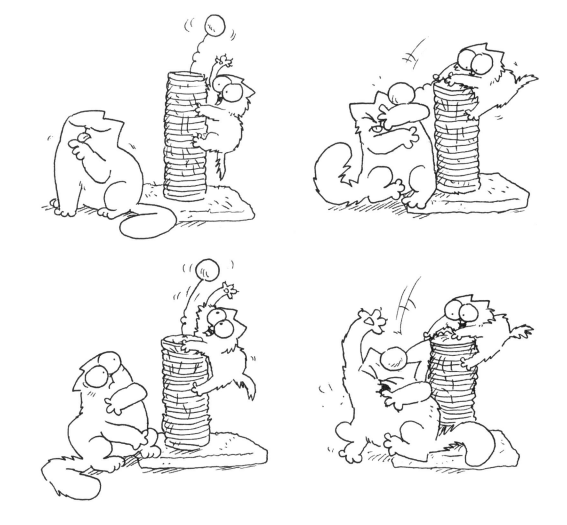

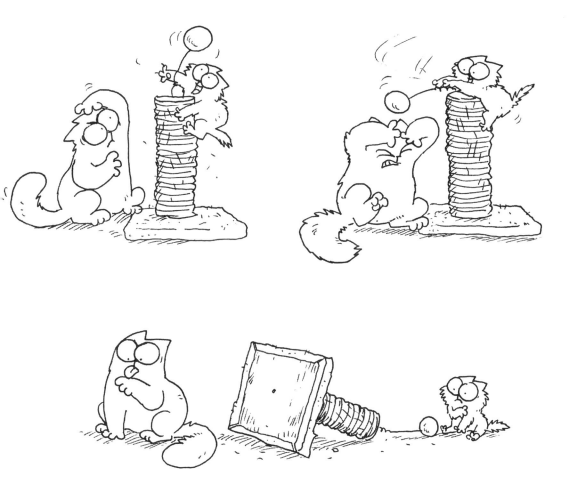

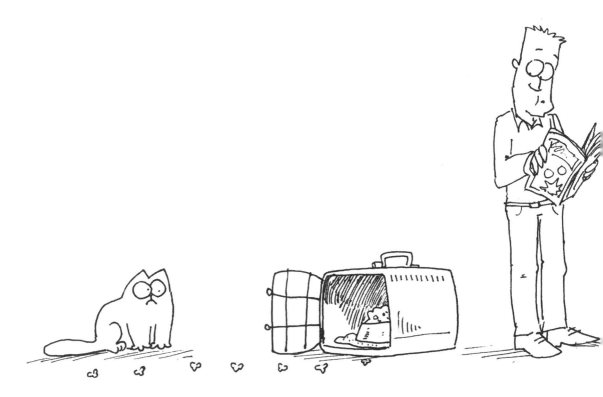

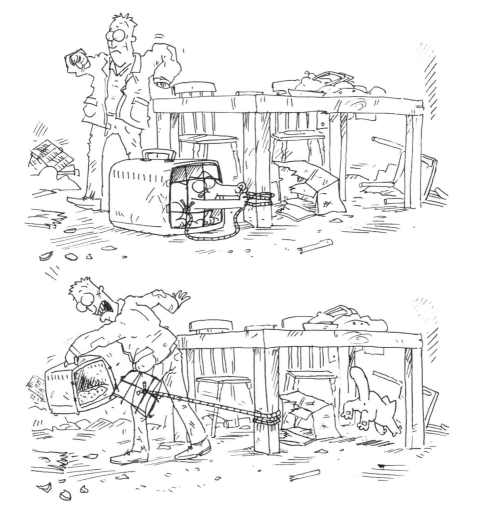

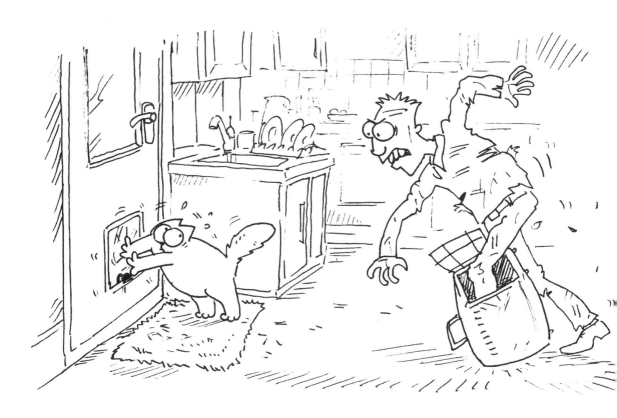

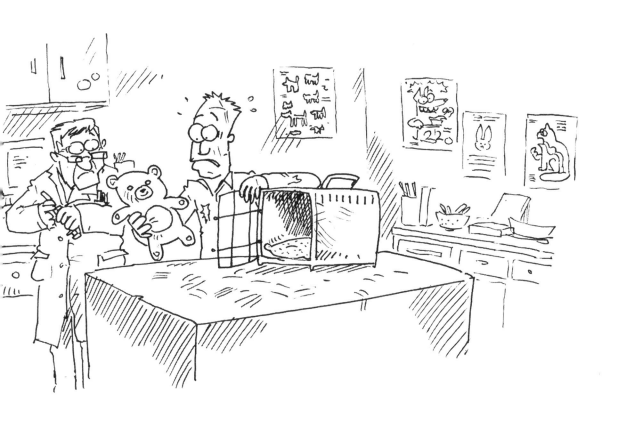

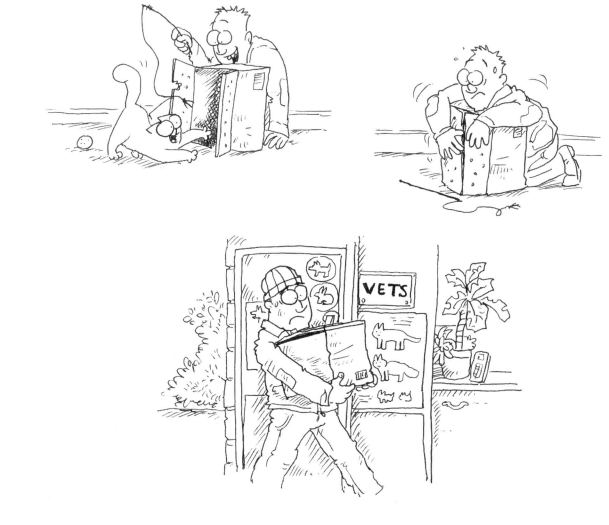

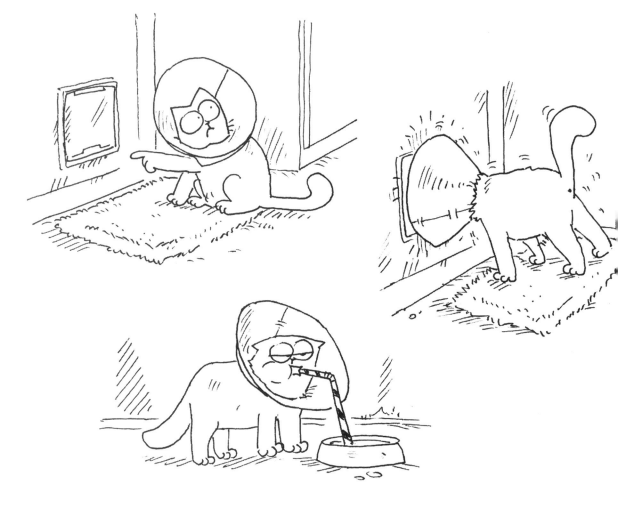

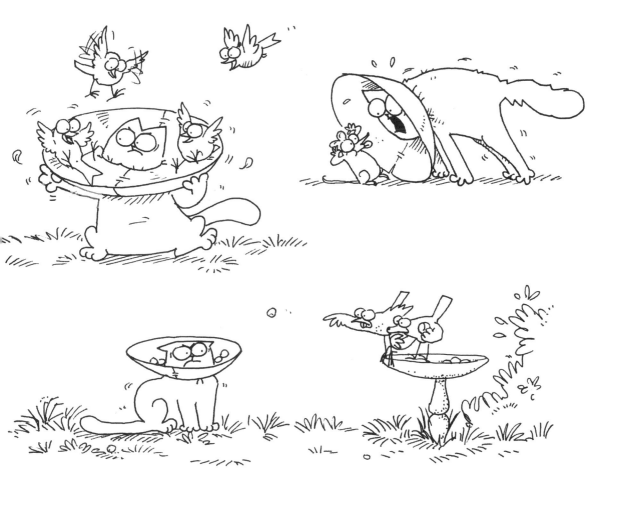

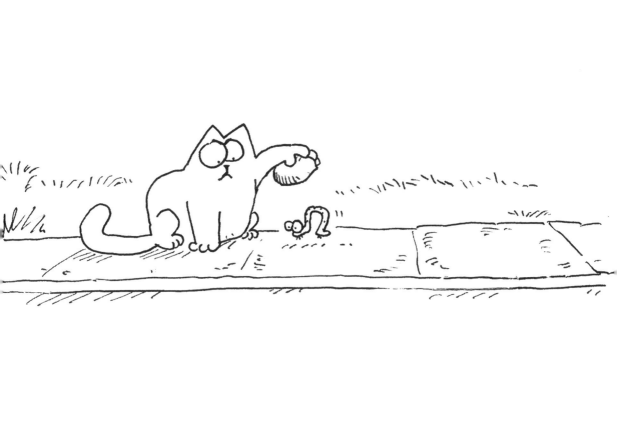

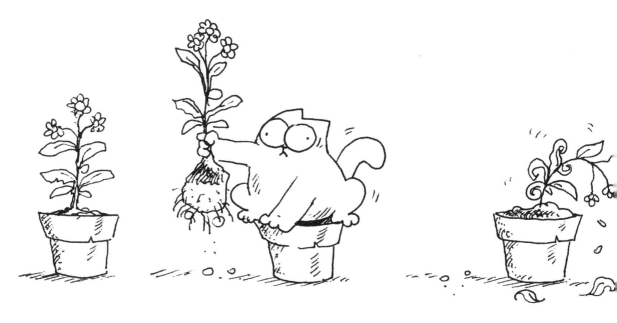

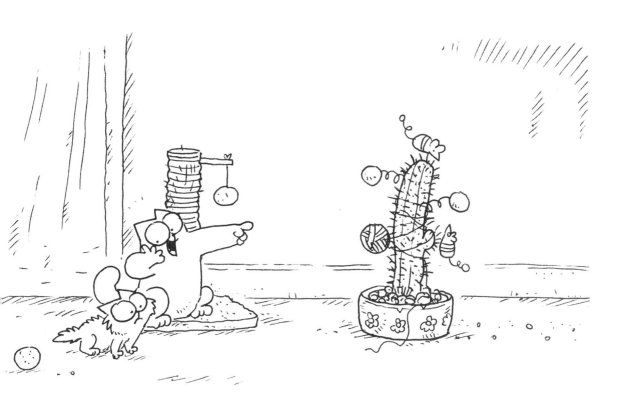

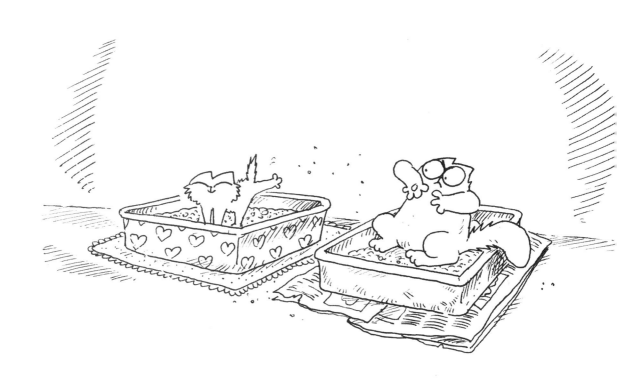

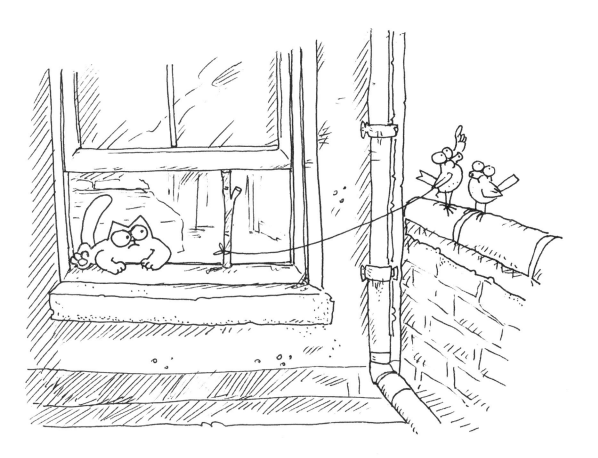

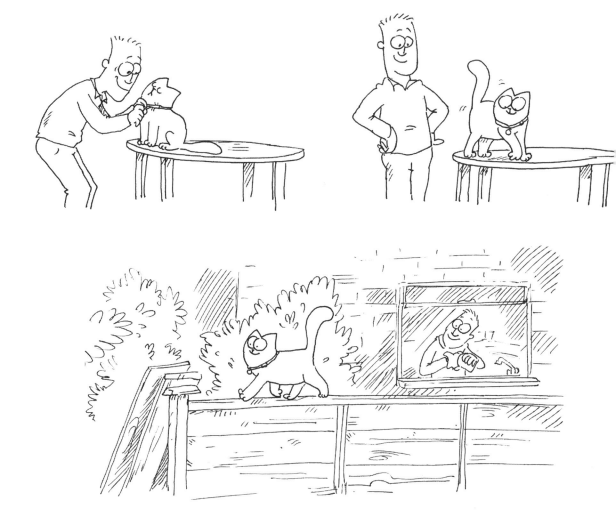

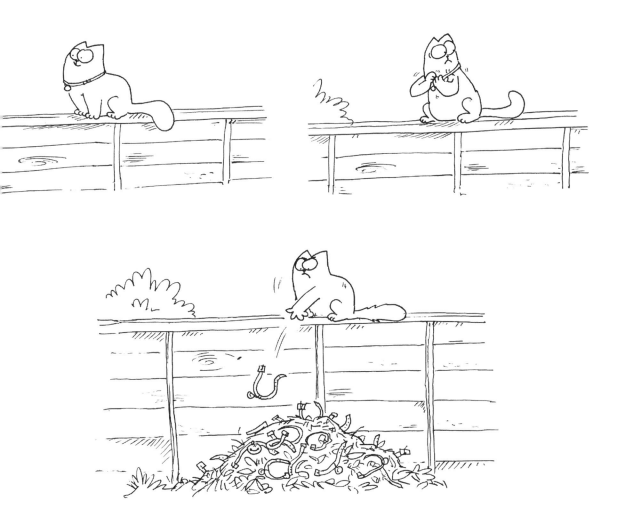

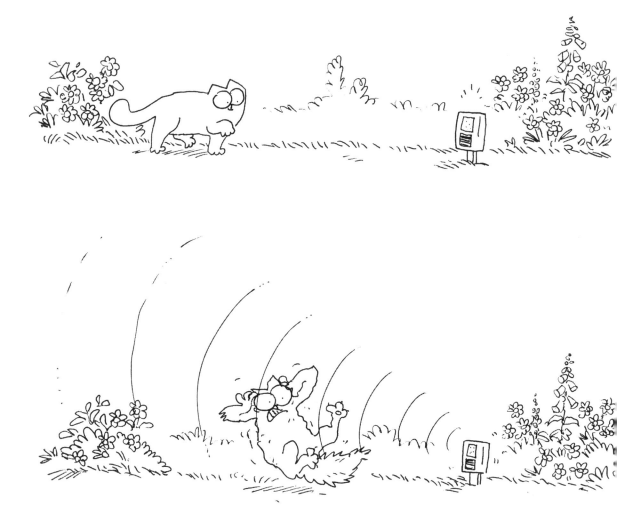

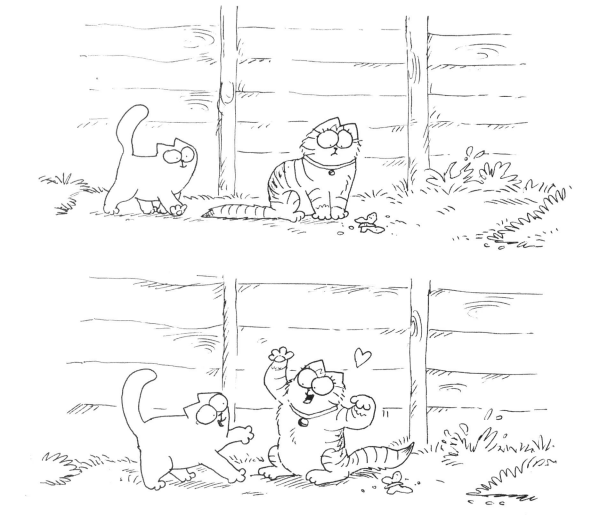

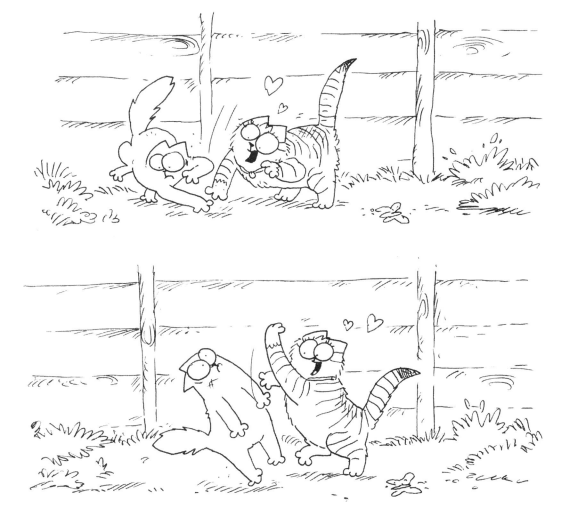

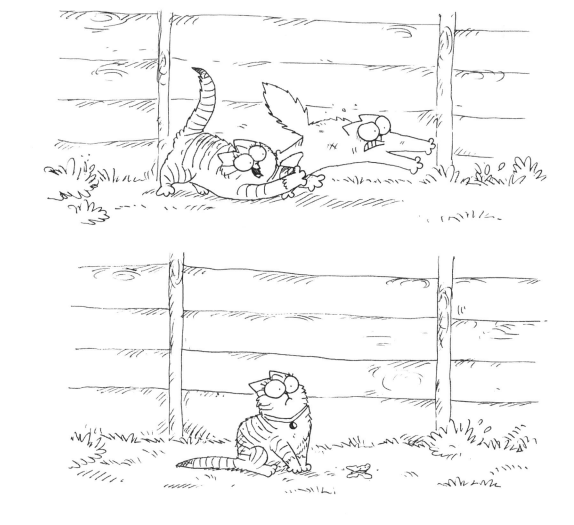

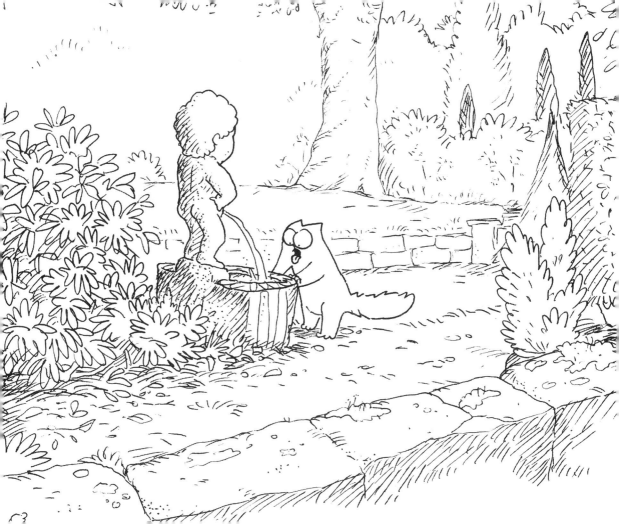

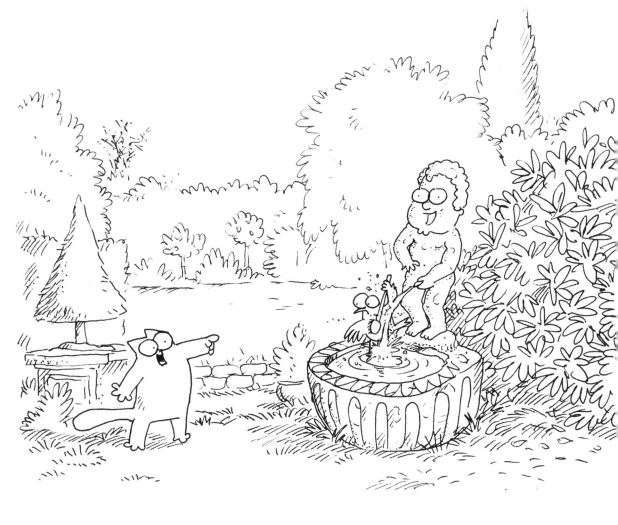

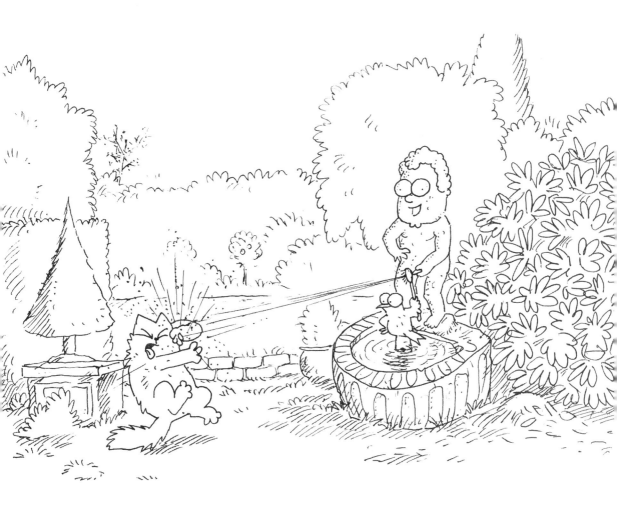

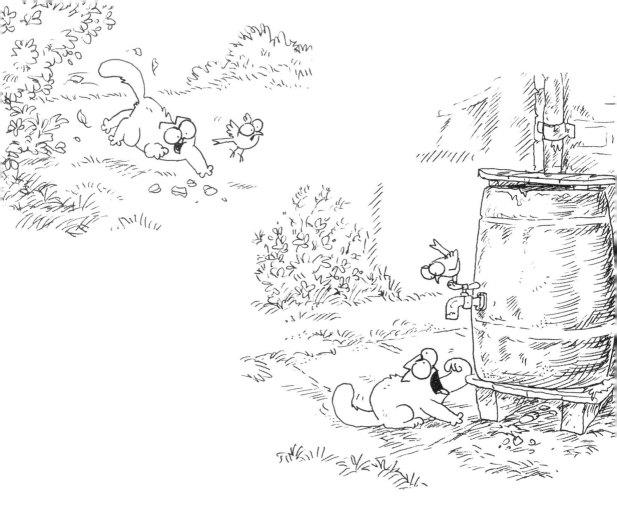

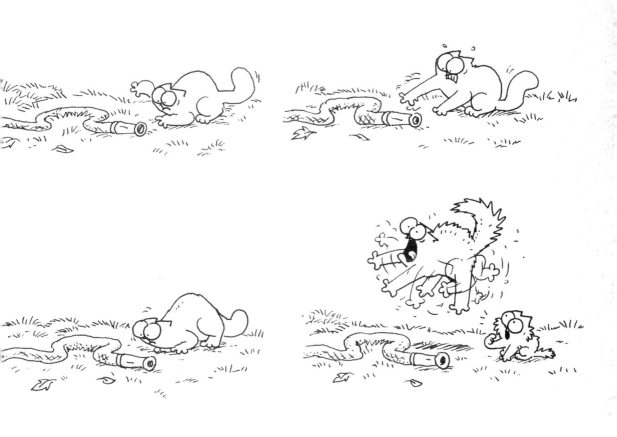

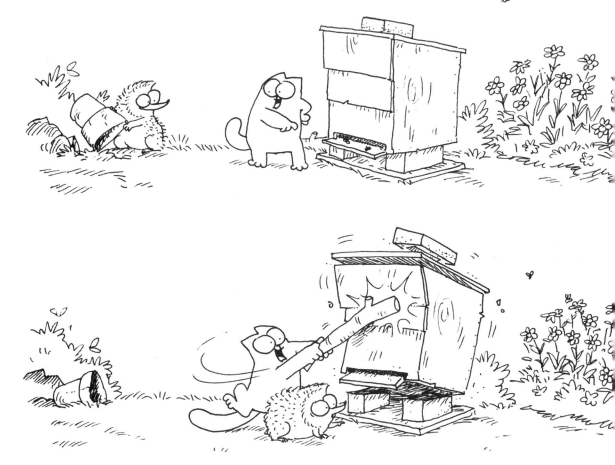

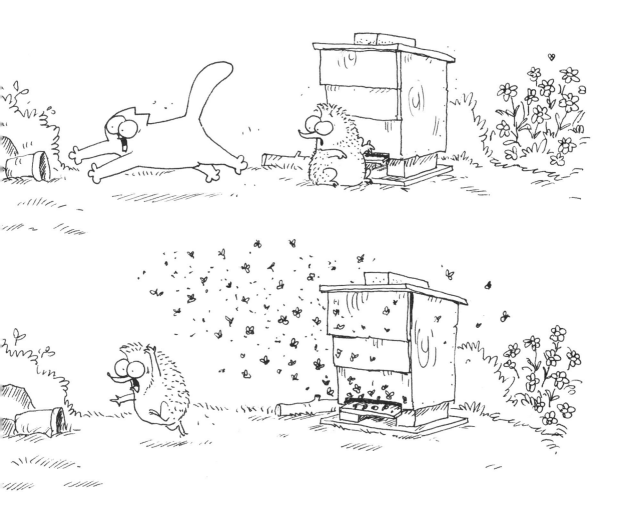

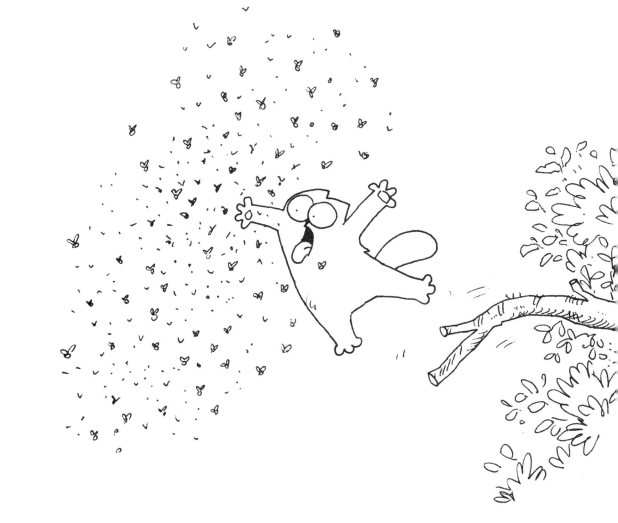

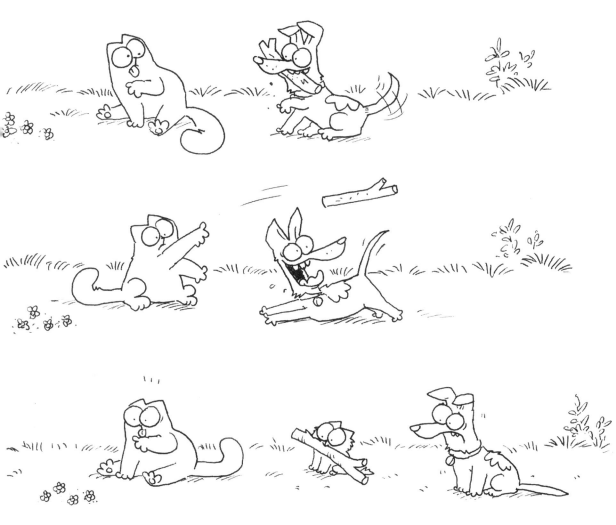

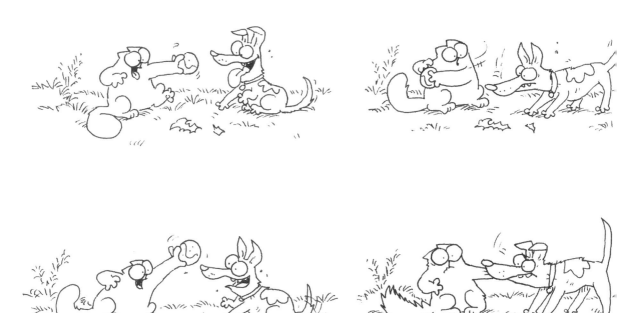

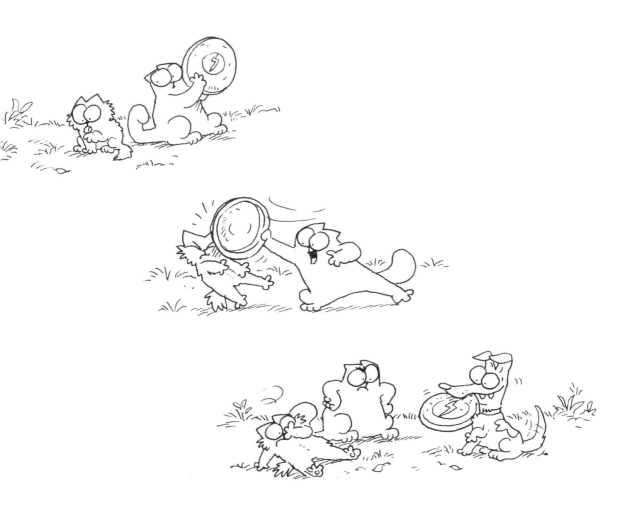

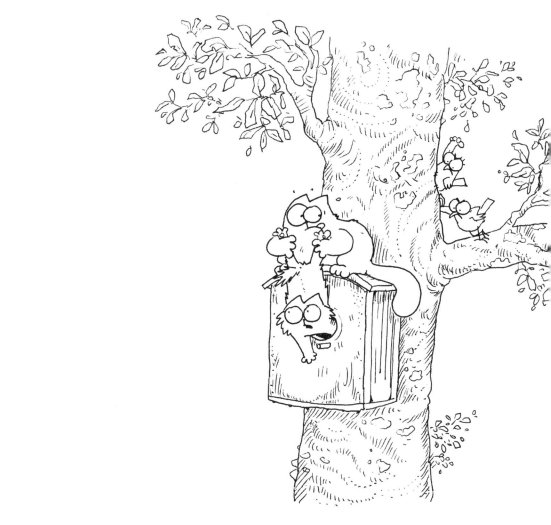

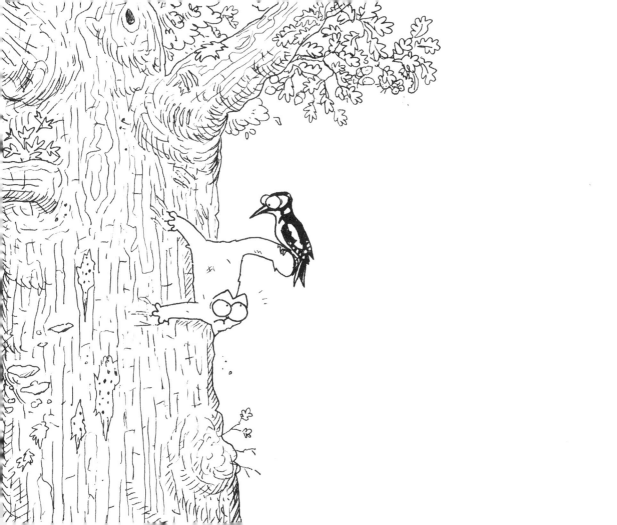

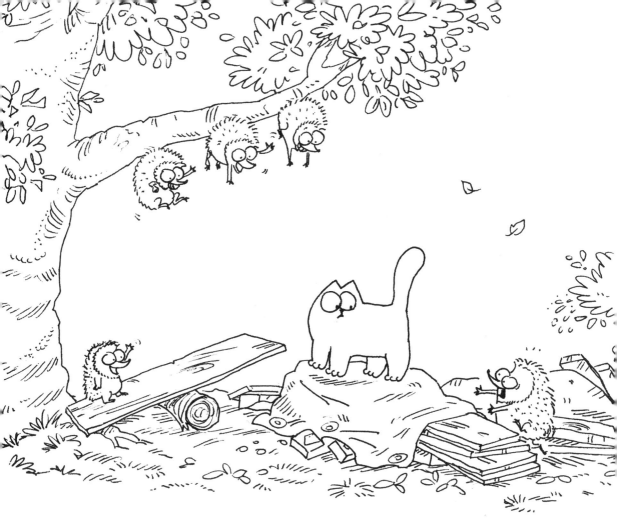

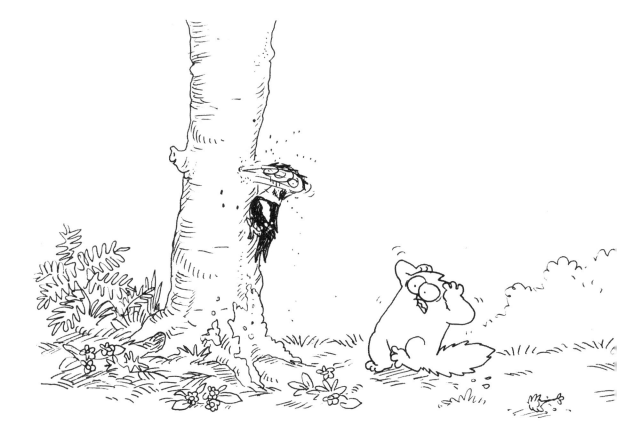

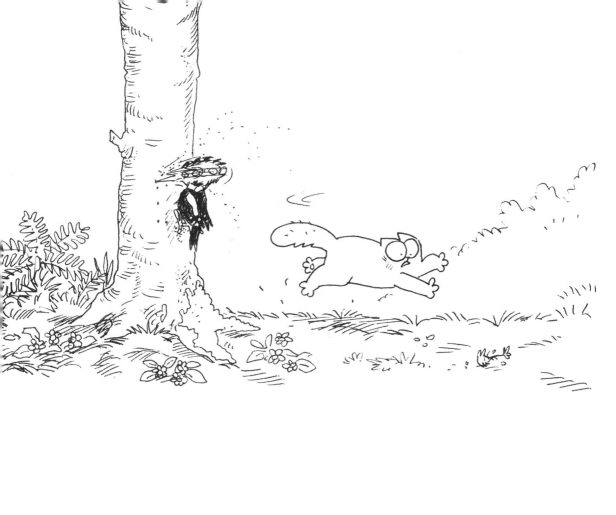

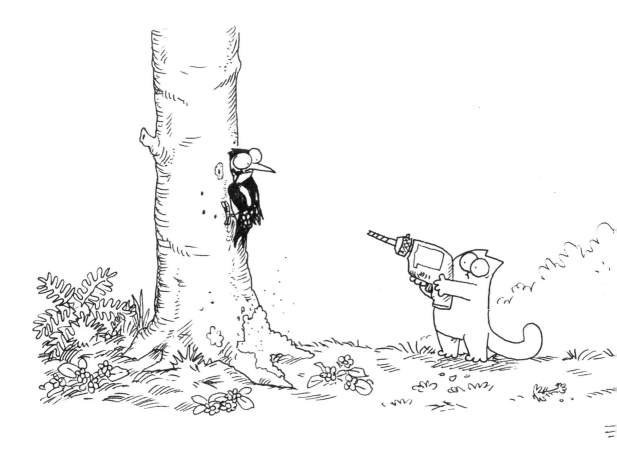

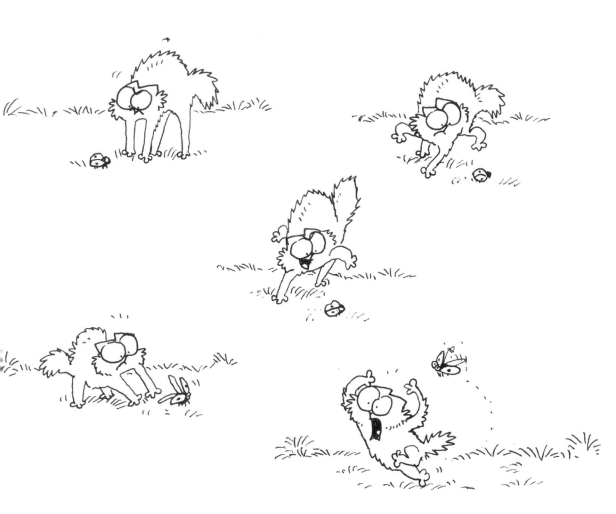

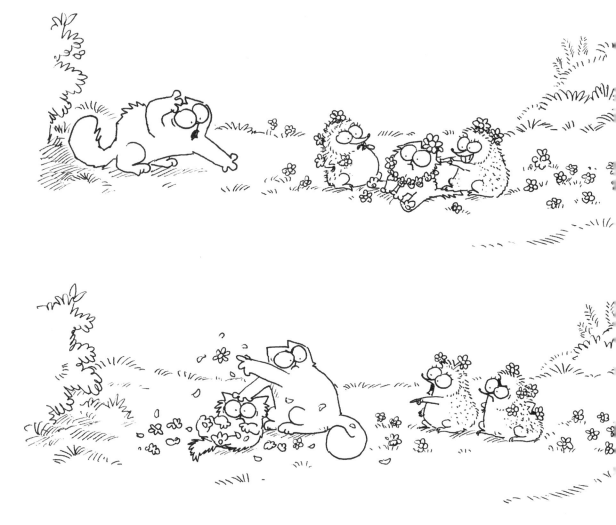

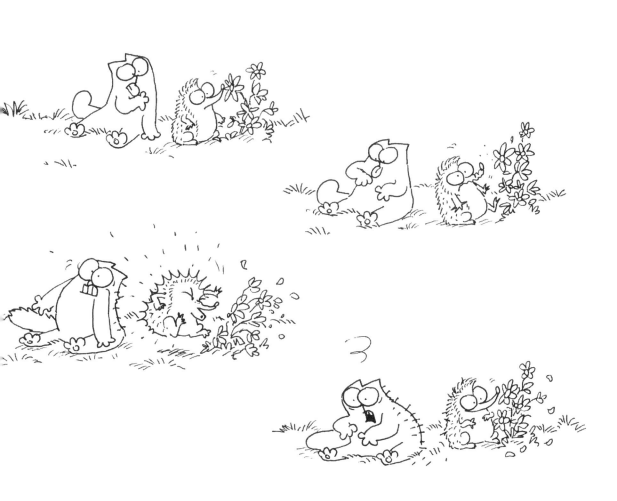

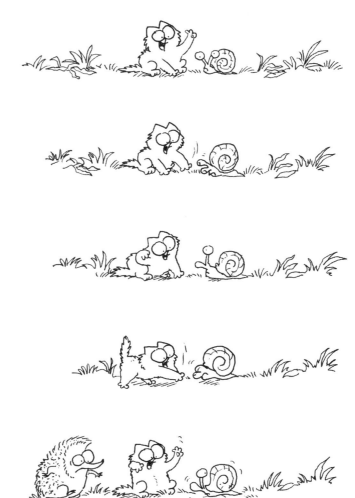

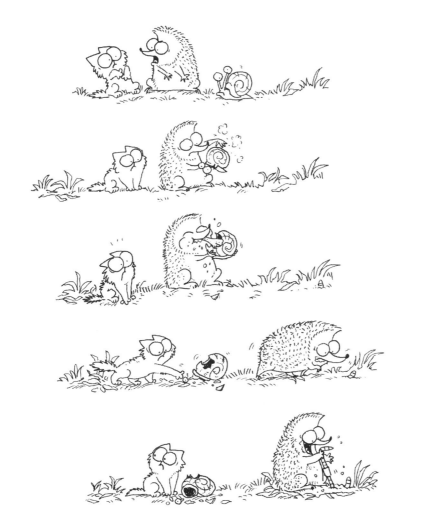

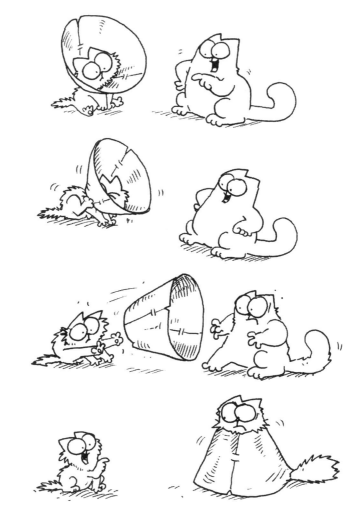

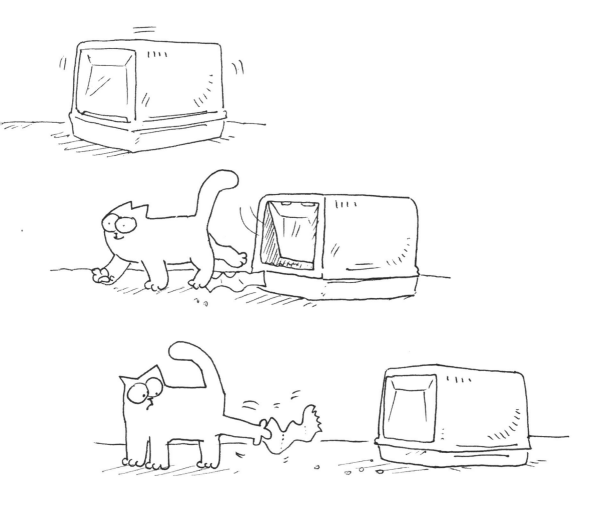

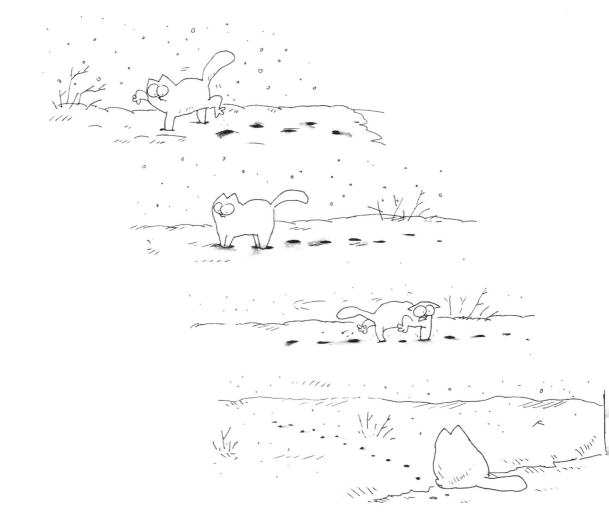

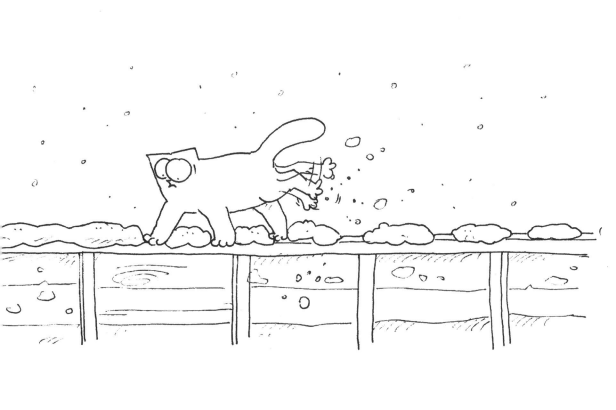

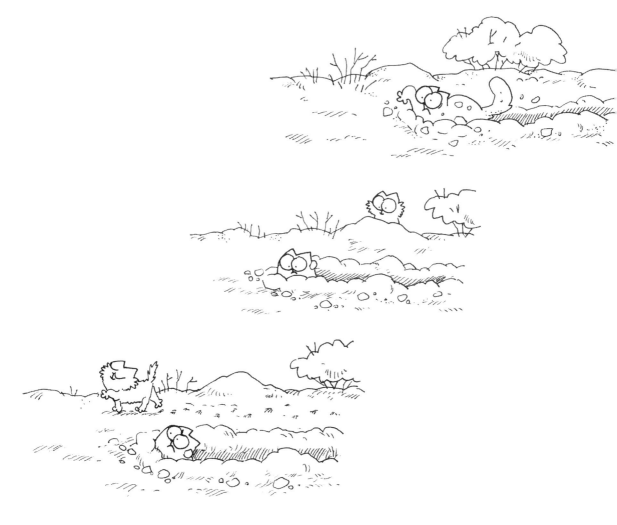

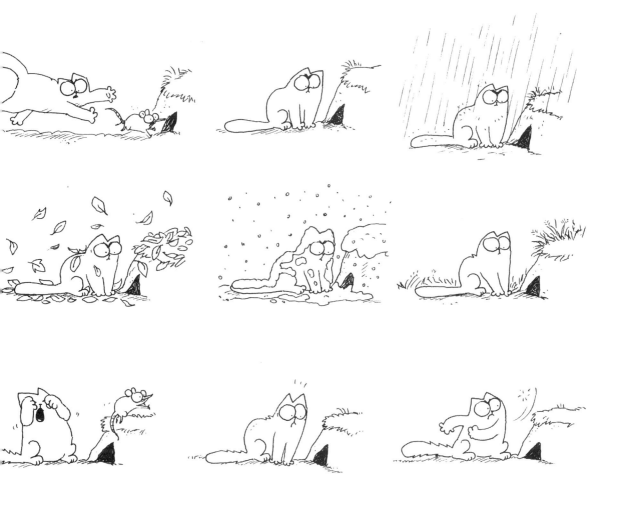

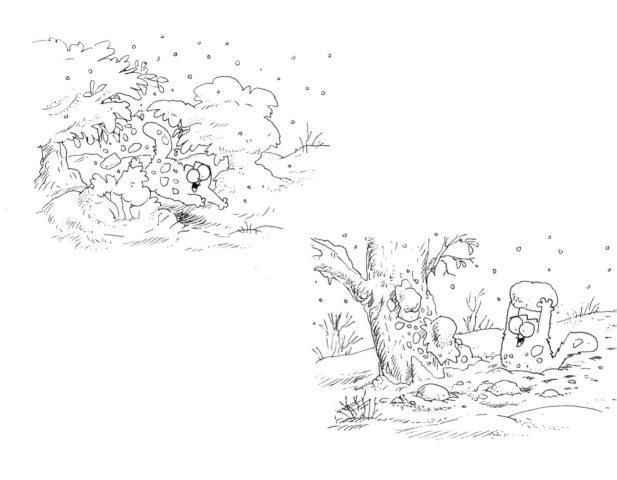

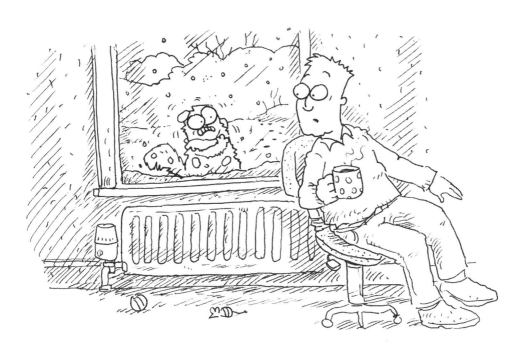

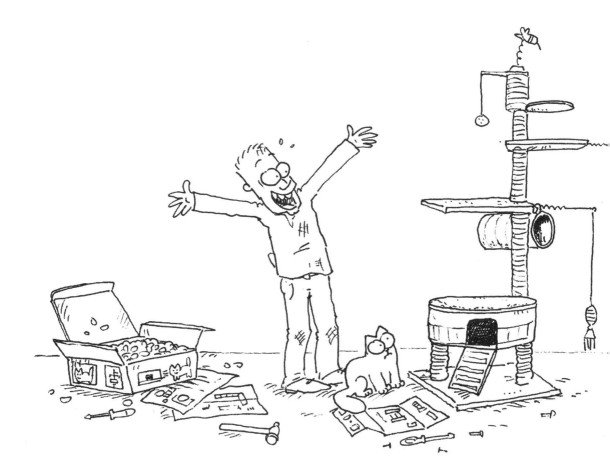

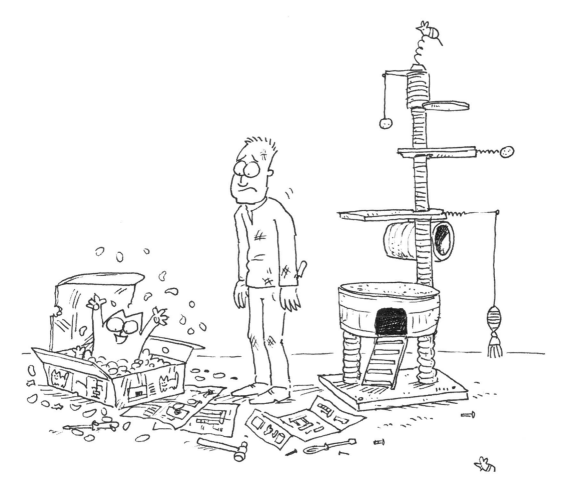

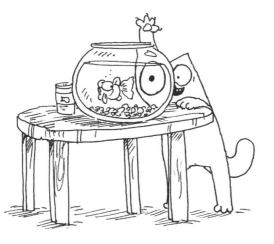
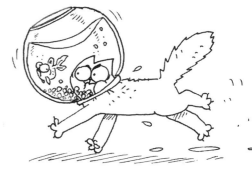

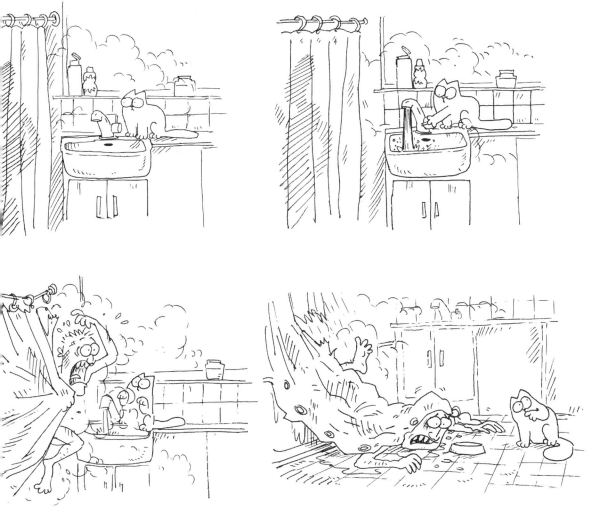

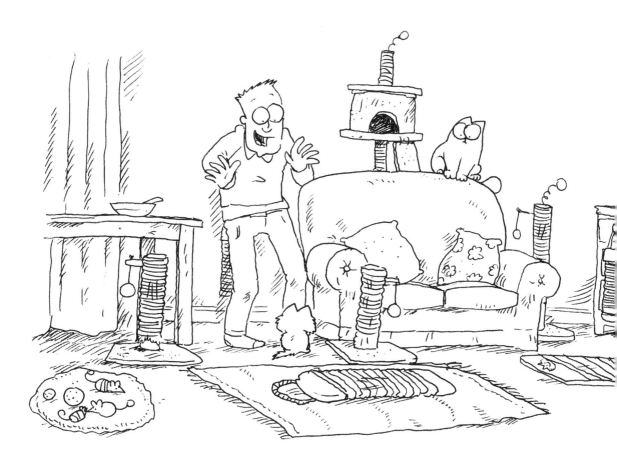

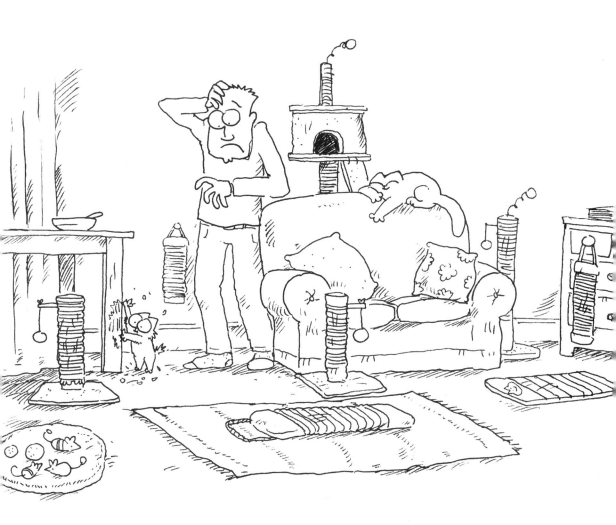

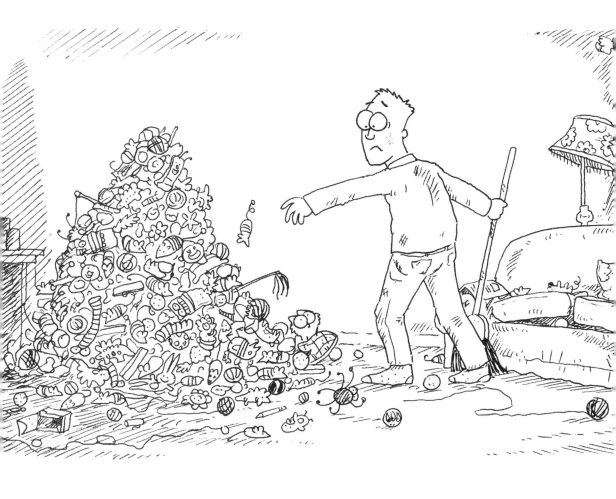

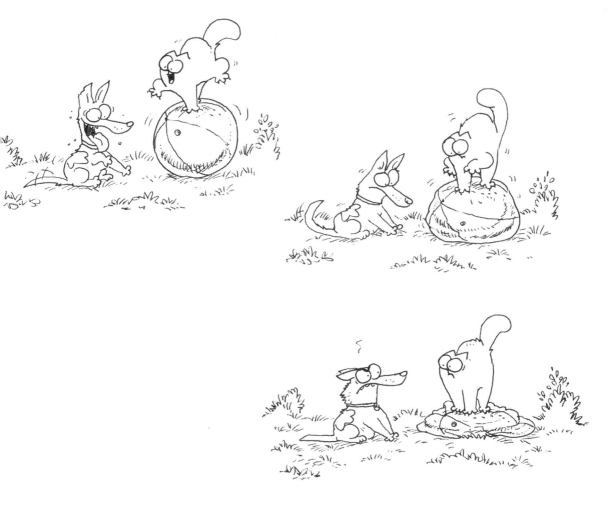

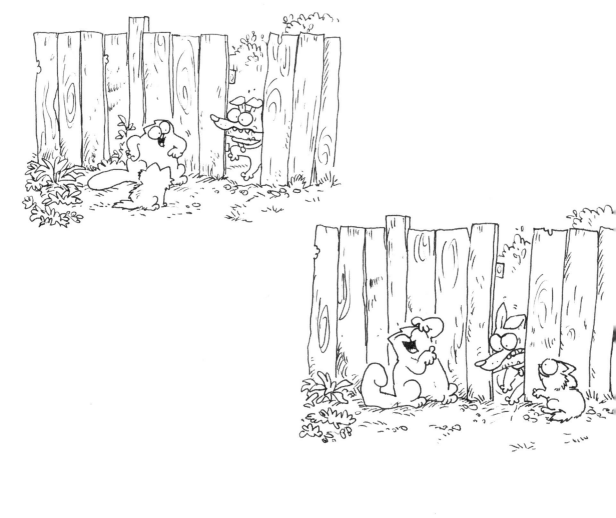

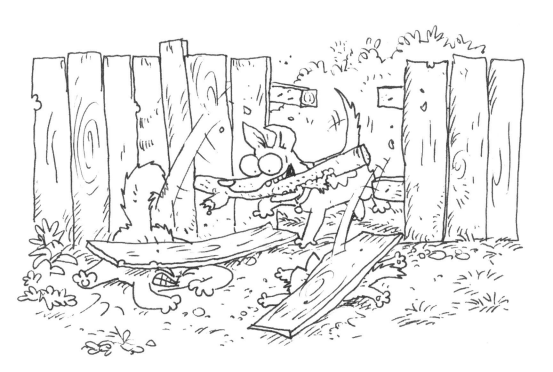

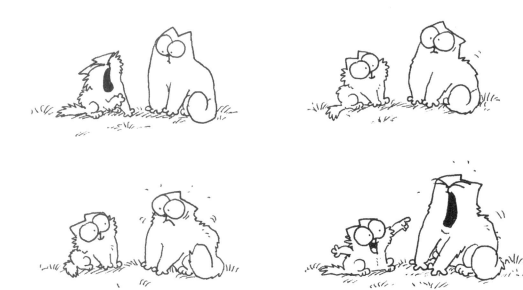

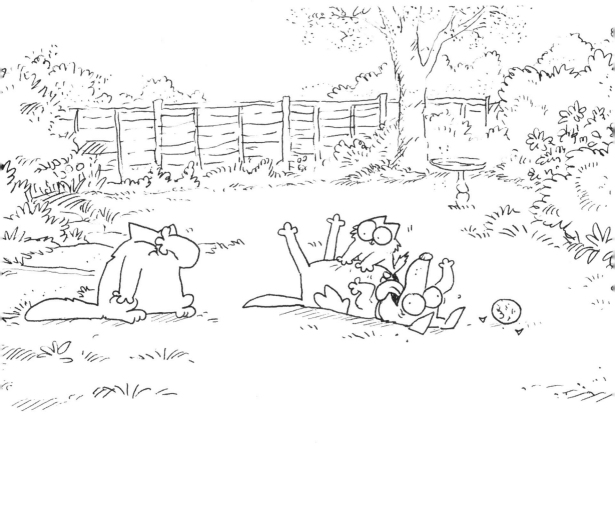

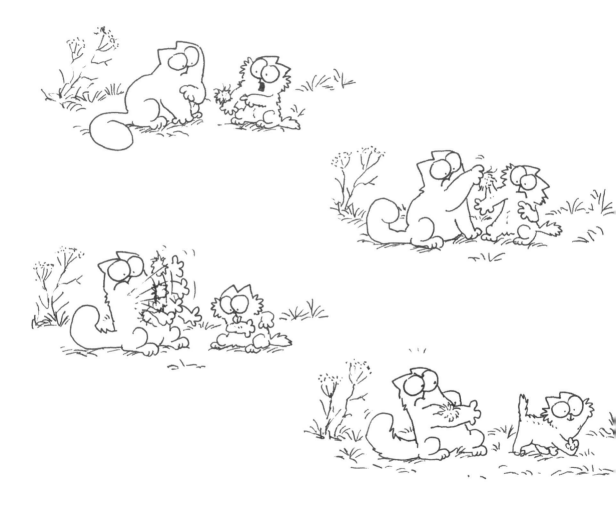

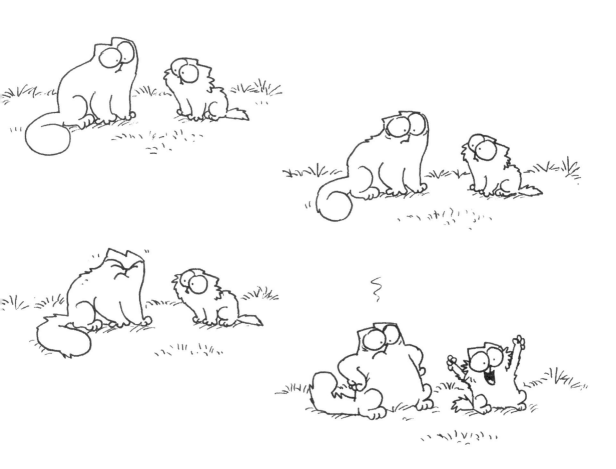

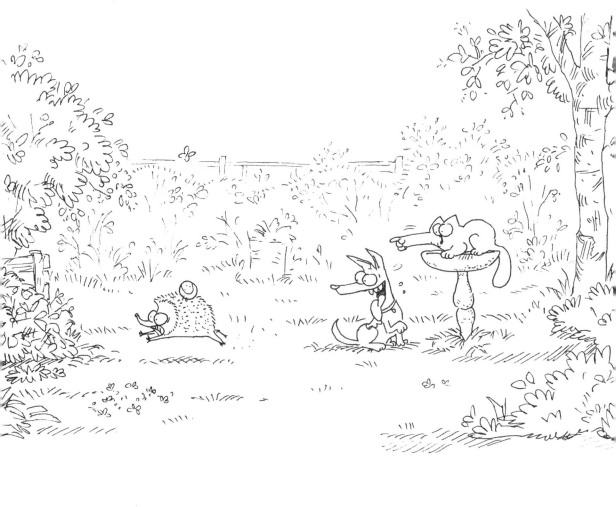

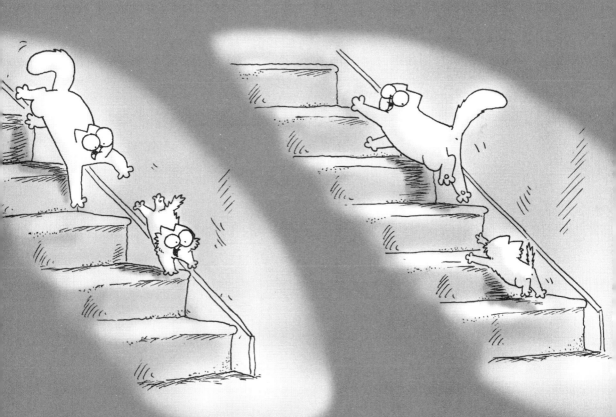

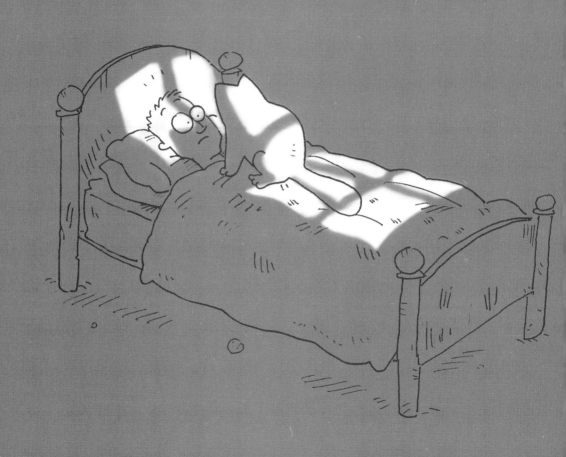

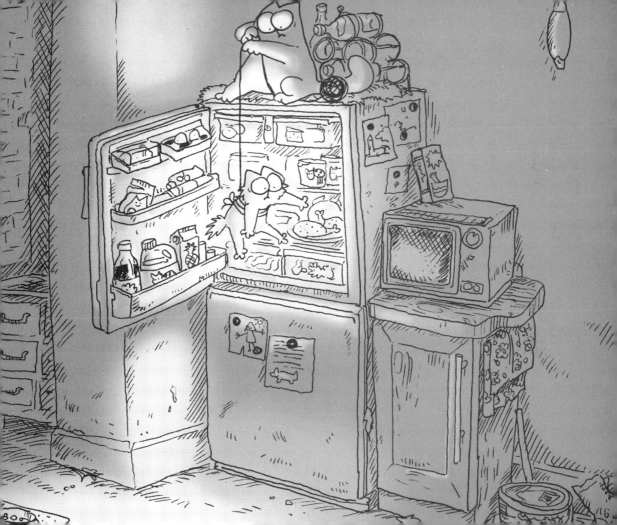

Simon Draws : Simon

1:

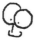

To draw Simon, (that's me), start with two eyes and the nose.

2:

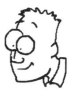

It's a cartoon of myself: spiky hair, mouth, face and collar.

3:

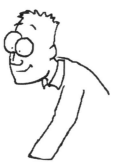

In this pose I'll be kneeling down so I draw my arm stretching down to the floor.

4:

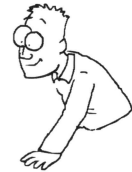

I draw the hand flat on the ground with the fingers spread apart.

5:

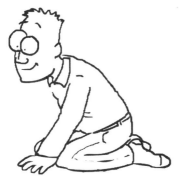

In this crouched pose, I draw my legs bent double under my body.

6:

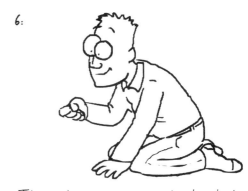

The other arm is raised: clenched fingers gripping on to something.

7:

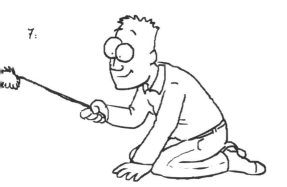

In the raised hand I draw a cat toy: a stick with a fluffy end.

8:

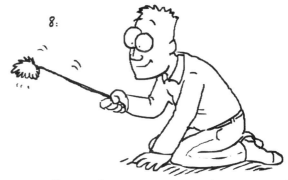

Finally I add movement lines around the toy and a ground shadow.

Simon Draws : The Dog

1:

To draw the dog, overlap the
eyes slightly, then draw a long nose.

2:

The dog is always alert,
so I draw his ears pricked-up.

3:

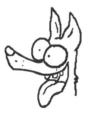

He has a big floppy tongue lolling
out of his mouth. I draw three teeth.

4:

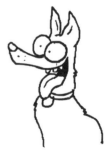

I give the dog a collar, then
draw his body. His chest sticks
out slightly.

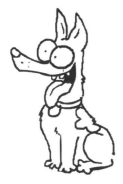

The body leads down to long
bony legs.

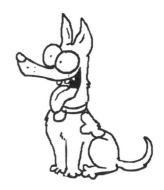

He's excited and wags his
pointy tail.

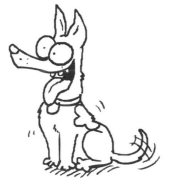

Jack Russells are full of energy. I
like to draw them shivering and shaking.

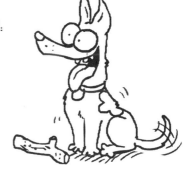

Finally, let's give him a
stick to run after.

\intimon Draws : A Rabbit

1:

Start drawing the rabbit with round eyes then a little 'U'-shaped nose.

2:

Just under the nose, draw the rabbit's little mouth.

3:

Straight up above the eyes draw two big rabbit ears.

4:

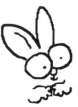

Draw two tiny front paws, these make the rabbit look very cute.

5: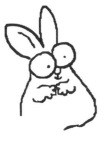

Next I draw a very simple
pear-shaped body.

6: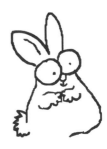

The fluffy tail is drawn
just behind the body.

7: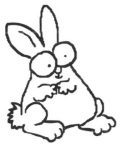

Rabbits have these great big hind legs
and feet.

8: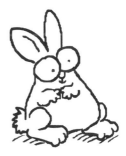

Finally I give the bunny a
ground shadow.

\intimon \mathcal{D}raws : A Mouse

1:

2:

Start drawing the mouse with big round eyes.

This mouse has a snout that curves upwards towards the end.

3:

4:

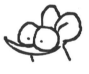

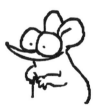

This is a wood mouse so I'll draw quite large round ears.

Two small front paws will make him look very cute indeed.

5:

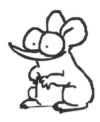

The mouse has a pear-shaped body, with large hind legs and feet.

6:

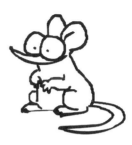

The mouse has a long curved tail.

7:

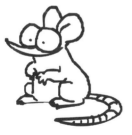

I like to add some ribbed lines to the tail.

8:

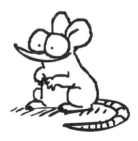

Finally I give the mouse his ground shadow.

Simon Draws : A Frog

1:

The frog starts with big round eyes.

2:

Below the eyes I then draw a big sad-looking mouth.

3:

The back of the frog's body is smooth and the front bulges out.

4:

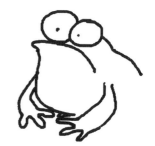

The front legs are thin at the top, then fatter at the bottom. They curve inwards under the body

5:

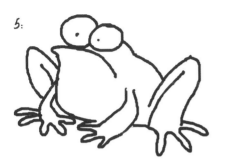

The rear legs are much bigger.

6:

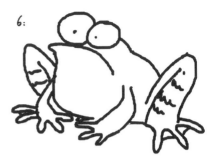

I add striped markings to the back legs.

7:

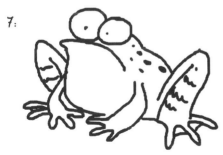

Now I'll draw some black dots on the frog's back.

8:

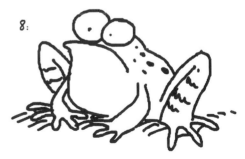

Finally I give the frog a ground shadow too.

\intimon Draws : The Hedgehog

1:

First draw the hedgehog's big round eyes, then a pointy snout.

2:

First draw the hedgehog's big round eyes, then a pointy snout.

I draw the back next, but use a dashed line to show his spines.

3:

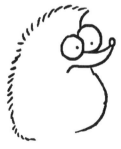

He has a rounded pear-shaped body and a fat belly.

4:

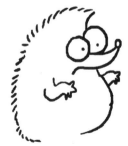

I draw him with tiny little arms.

5:

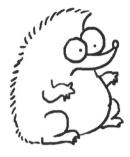

He also has small rodent-like feet.

6:

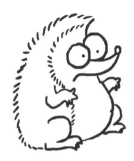

I draw another dashed line to split the body and chest areas.

7:

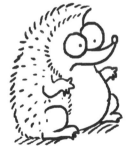

Fill in the back area with dots, he's got lots of prickly spines.

8:

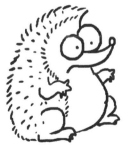

Finally I give him a little ground shadow.

Simon Draws : The Kitten

1:

To begin, I start by drawing the eyes.

2:

I then add a small nose and mouth, typical of kittens.

3:

Above the eyes, I add my signature 'M' shaped ears.

4:

The head is completed by adding big fluffy cheeks.

Kittens have short legs,
but surprisingly big paws.

Kittens have huge heads
but tiny bodies.

The kitten has a little tail which
points straight up when he's happy.

Finally, let's add some shading
for his ground shadow. MEW!

Simon Draws : Simon's Cat

1:

Let's start by drawing two big round eyes.

2:

Simon's Cat is always hungry, so I draw him with a big wide open mouth then shade it in.

3:

Next, the cat's ears: you can draw both ears with a single line shaped like the capital letter 'M'.

4:

I'm drawing the classic 'Feed Me' pose, so here's his paw pointing into his gaping mouth.

5:

I draw the other three legs next.
He's got little dumpy legs and paws.

6:

Simon's Cat has a great big
fat fluffy tail.

7:

I like to add hatching lines to
show a ground shadow.

8:

Finally, let's give him his food bowl,
MEOW!

See video tutorials of Simon's drawing lessons online at youtube.com/simonscatextra

INTRODUCING

Simon's Cats

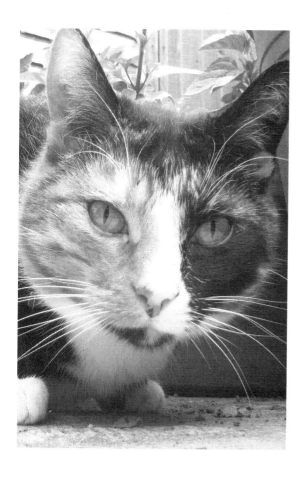

Jess

Jess is a tiny tortoiseshell cat who is very shy of strangers but has a meow that can bring the house down.

She follows me constantly, letting me know she wants a fuss and reminding me of when it's time for food. She is the definition of 'lap cat' and the oldest of the gang being thirteen year old.

She certainly lives up to her 'naughty tortie' image and has crazy moments of tearing around the house, wrecking everything in her path.

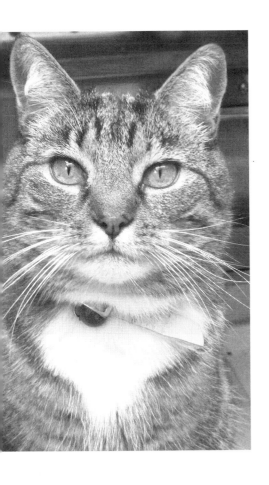

Maisy

Maisy is the undisputed queen of the house. She is a rescue cat and lived on the street for eight months. Even to this day she tries to cover her food to save it for later if she can't eat it all.

She loves the outdoors and enjoys long sessions of sunbathing in the garden. She also loves a game but tends to play a bit too roughly for the other cats to join in.

Although she puts the other cats in their place at feeding time, Maisy is as gentle as a kitten with me. She loves to sleep on my pillow, keeping me awake with her deafening purr.

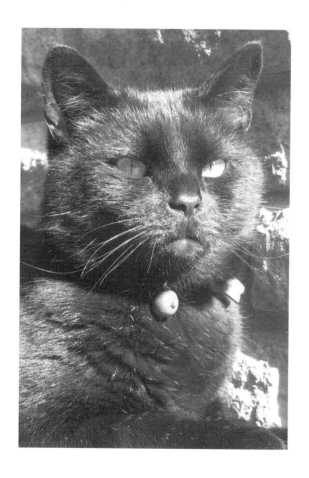

Hugh

Hugh is the big softie of the house and his tiny high pitched 'mew' lets me know it's eight o clock and time for dinner every night.

When he was a kitten he took to licking my ear in the morning which I thought was cute. Now he is the size of a small bear, the cute thing has worn off!

He is also a sucker for attention and loves having his head and belly tickled. He, like Maisy, loves the outdoors and can often be seen sleeping on the neighbour's roof in the sun.

Hugh was the kitten who gave me the idea to create Simon's Cat.

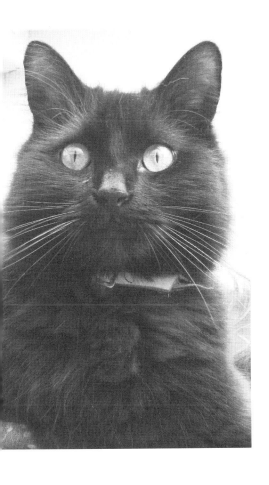

Teddy

Teddy came into my life after I heard the sad story of how he was left in a box in a field. He is such a character and always makes me laugh with his antics. He loves to climb things and spends most of his time high up looking down on the world.

I think he might have a little Maine Coon in him because he has a glorious long coat. He also loves to sit in the rain and get totally drenched. He then proceeds to walk around like a wet mop soaking everything.

Teddy was the tiny long-haired kitten that helped me draw *Kitten Chaos*. All my cats continue to help me with inspiration in their own unique ways.

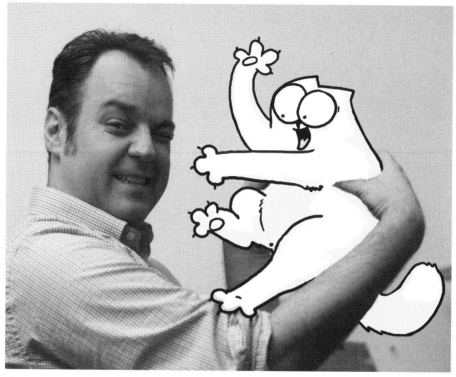

Simon Tofield is an award-winning animator and cartoonist. He has had a lifelong interest in animals, beginning as a child, when his uncle gave him a plastic pond which quickly filled with wildlife. Simon was given his first cat when he was nine and now has four rescue cats, who are the mischievous inspiration for his work.

Acknowledgements

Zoë Tofield, Nigel Pay, Laura Nailor, Emma Burch, Mike Cook, Isobel Stenhouse, Chris Gavin, Daniel Greaves, Mike Bell, Jenny Lord and the Canongate team. Robert Kirby at UA and of course my four inspirational cats.

For all your Simon's Cat goodies,
check out the webshop at www.simonscat.com